DATAMBER MINDPAPER

ATTACK ON THE SCREENAGERS

STEWdio
THE NAPHIC GROVEL ARTrilogy OF CHUCK D

VOLUME III
NOVEMBER 2021–FEBRUARY 2022

ENEMY
BOOKS

Published by Enemy Books/Akashic Books
©2023 Mistachuck

STEWdio (Box Set) ISBN: 978-1-63614-100-8
Datamber Mindpaper ISBN: 978-1-63614-121-3
Library of Congress Control Number (for the full *STEWdio* box set):
 2022947060

Enemy Books is an imprint of Akashic Books
Instagram: mrchuckd_pe
Twitter: MrChuckD
rapcentralstation.net/enemy-books

Printed in China

Akashic Books
Brooklyn, New York
Instagram, Twitter, Facebook: AkashicBooks
info@akashicbooks.com
www.akashicbooks.com

FORGET THE DAMN
ASTEROID
WE ALREADY BEEN
HIT

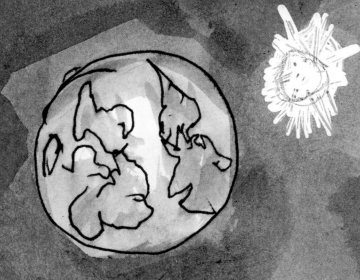

BY SHT WE CANT
SEE THAT MADE
THE WHOLE EARTH
SPLIT

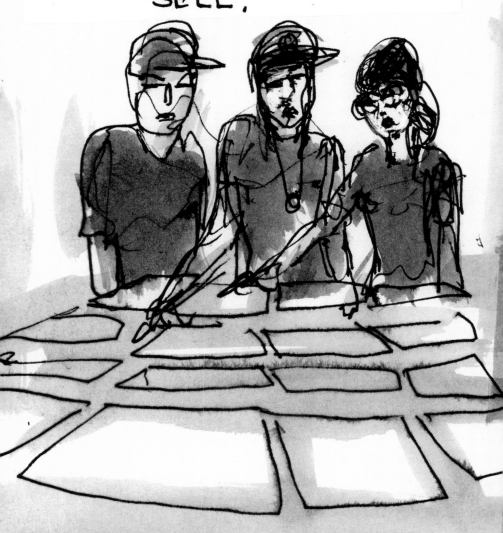

KIERAN 'WIZG' McIVER AND GIANA GAREL ARRANGE THE SCREENS OF DATAMBER WITH A PLAN TO SELL.

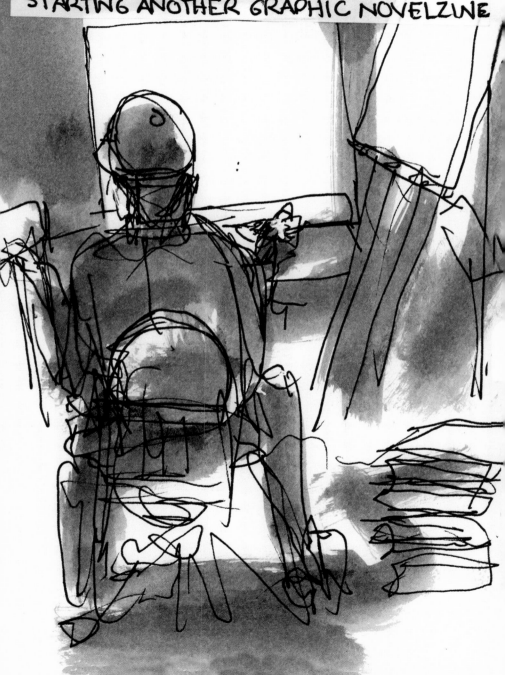

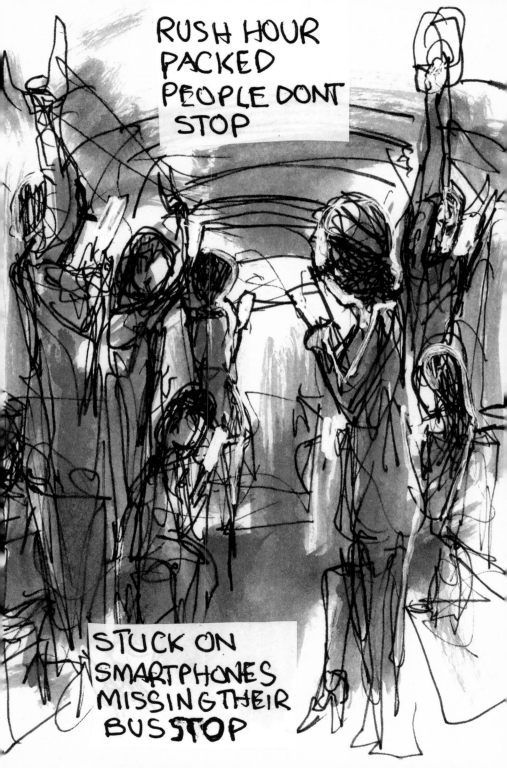

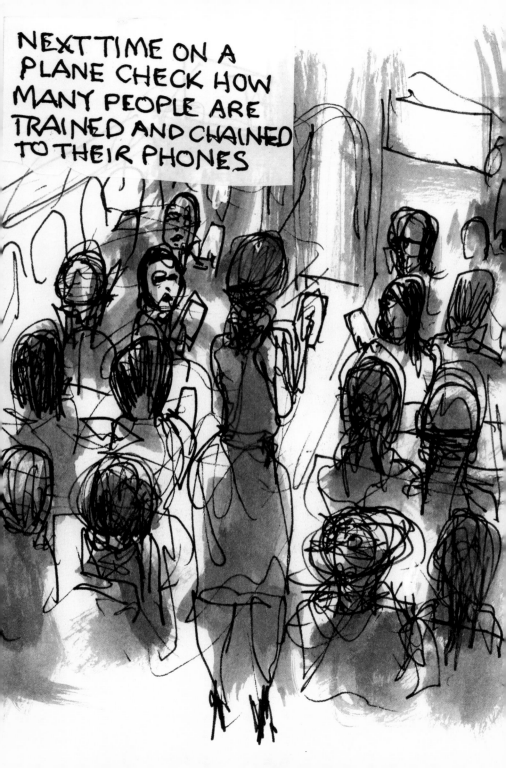

CROSSTOWN TRAFFIC BACK TO
BACK NOTHING IS FAST, BUT
BEST BELIEVE THERE'S A
SMARTPHONE AROUNOTHEIR DASH,

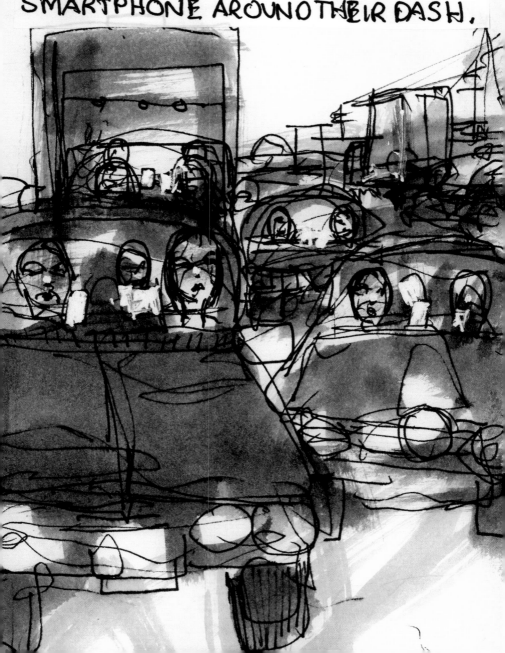

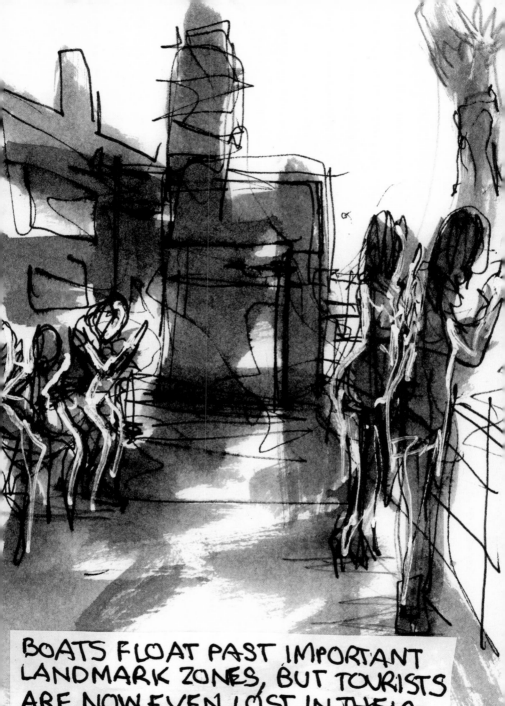

BOATS FLOAT PAST IMPORTANT
LANDMARK ZONES, BUT TOURISTS
ARE NOW EVEN LOST IN THEIR
SMART 'ASS' PHONES

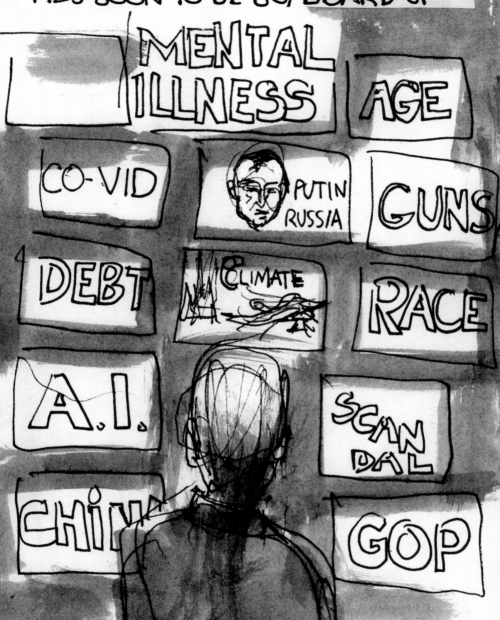

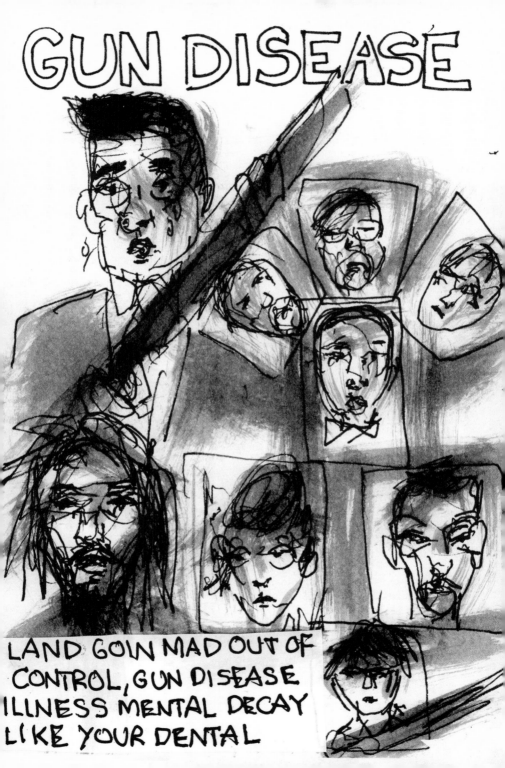

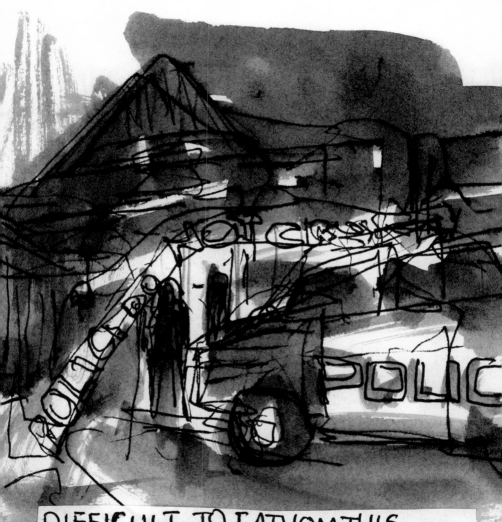

DIFFICULT TO FATHOM THIS
TRAGEDY OF MENTAL SICKNESS
RESULTING IN THE WORST THING
TO HAPPEN TO A ROYAL FAMILY

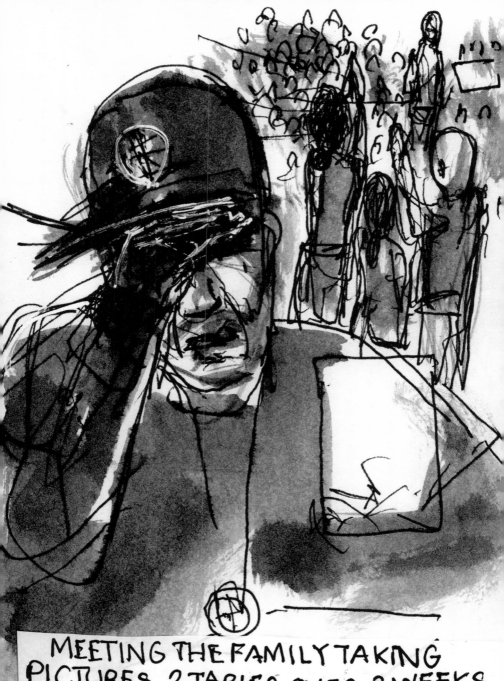

MEETING THE FAMILY TAKING PICTURES, 2 TABLES OVER 2 WEEKS AGO AT ROCK HALL IN CLEVELAND

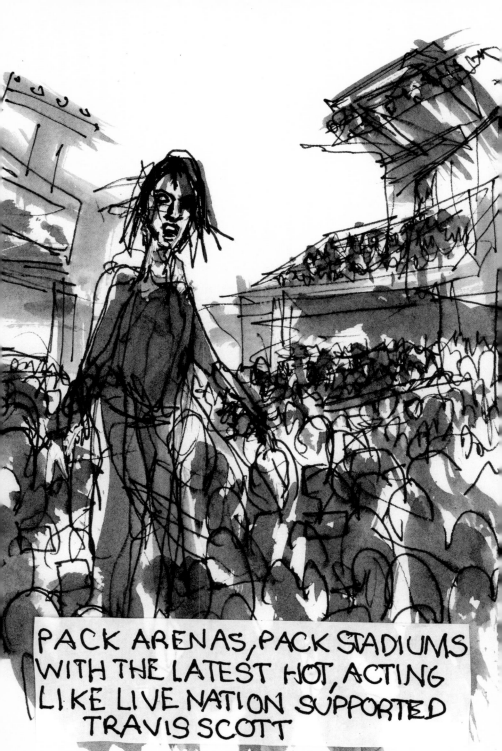

PACK ARENAS, PACK STADIUMS
WITH THE LATEST HOT, ACTING
LIKE LIVE NATION SUPPORTED
TRAVIS SCOTT

SHOT 1 SHOT 2 BOOSTER VAX
CO·VID STILL PUTTIN MASSES
LAID OUT ON THEIR BACKS

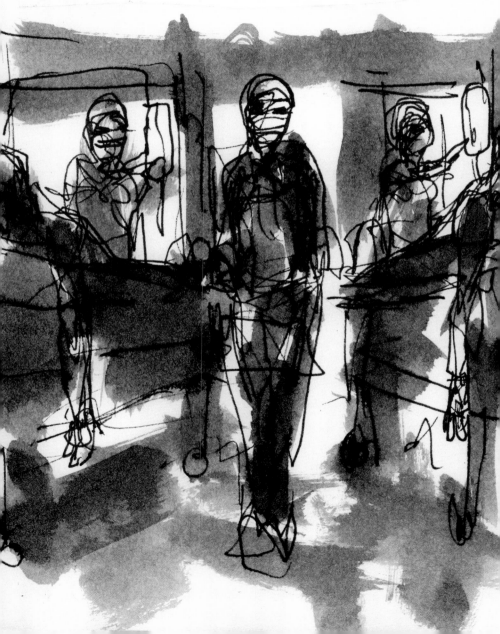

TEXAS AND FLORIDA NEED YOU
ASK, AUSTIN TO TALLAHASSE F CK
A DAMN MASK.

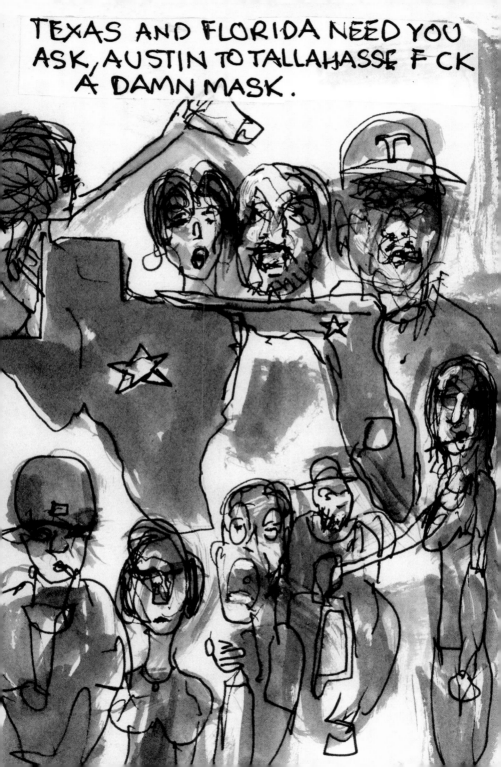

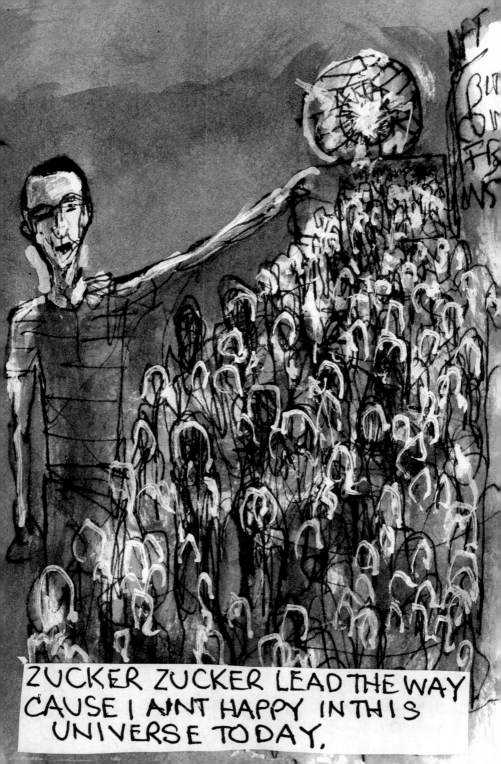

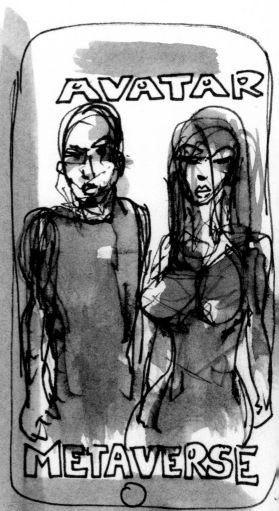

ONE CAN ONLY GUESS THE G.O PAYBACK
TRICKS IN POLITICS AND COINCEDENCE
ON LEAD SLIPPED ON ALEC?

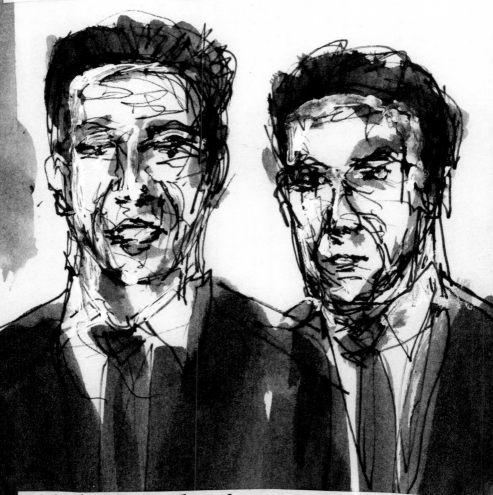

WHO KNOWS THE GAMES PLAYED AND
PAID BY A RIGHTED UNDERCOVER?

BUT I'D DO THE SAME DAMN THING
FOR MY BROTHER.

LOST ONE OF THE BEST ALL TIME WRITERS OF CHECKING CULTURE WE BANGED, BRO HUGGED... REST MY BRO IN PEACE AND BEATS GREG TATE

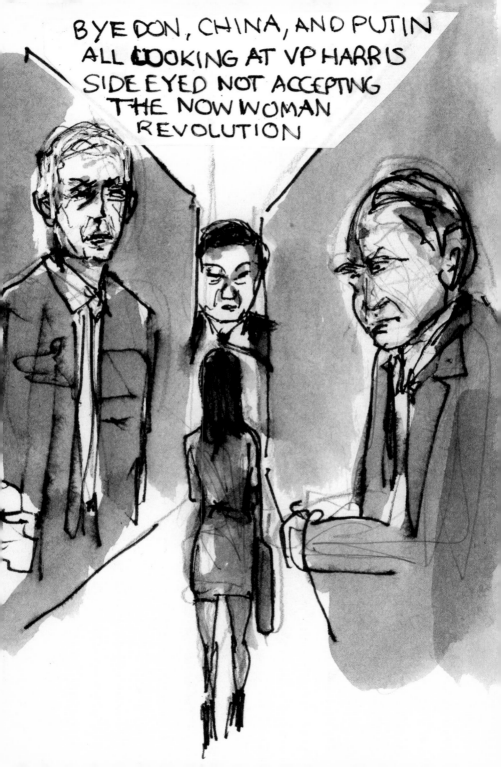

THE SENATE LATER PASSES BILL TO
AWARD THE CONGRESSIONAL GOLD
MEDAL POSTHUMOUSLY TO EMMETT TILL

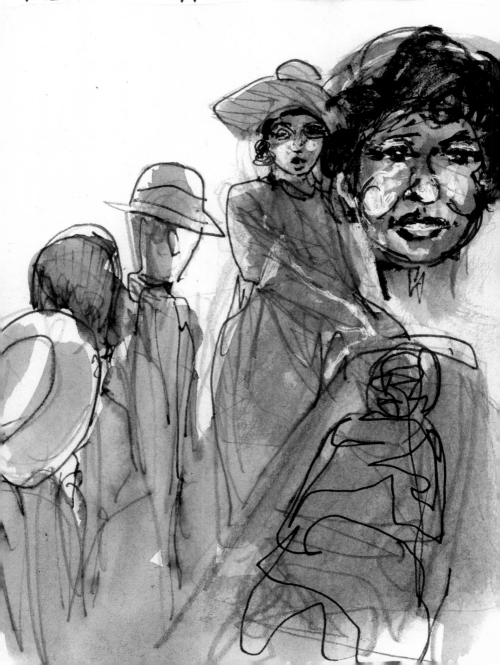

STILL SMH AT HOW EPSTEIN COMMITTED SUICIDE, NO CHANCE LETTING MAXWELL SLIDE.

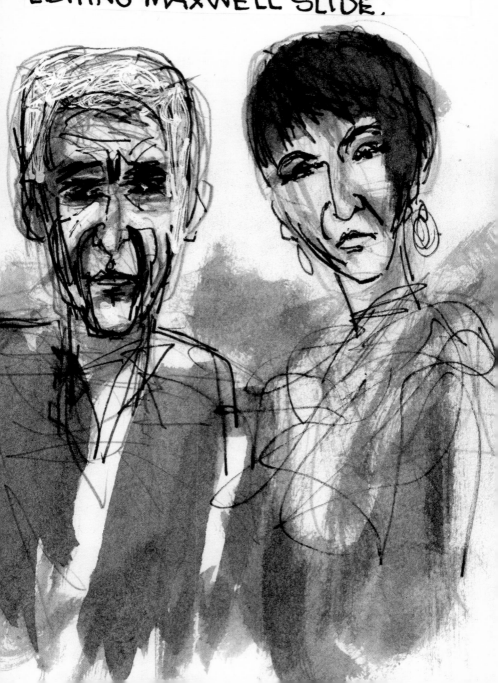

200 RAPPERS SHOT BY GUNS, LAST MONTH YOUNG DOLPH FROM MEMPHIS TODAY 400 SLIM ANOTHER LA SUN.

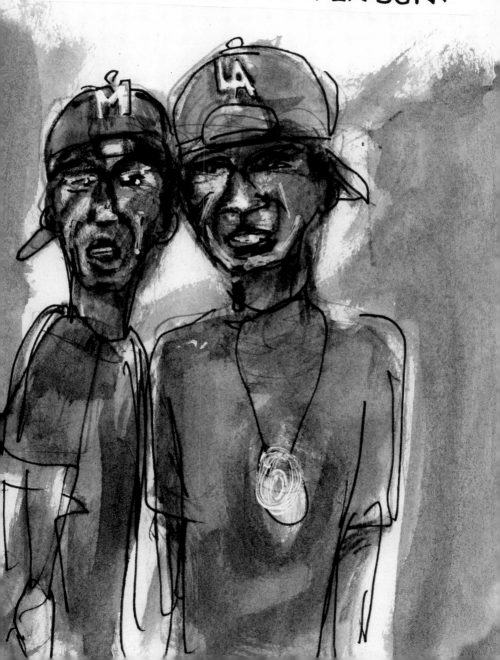

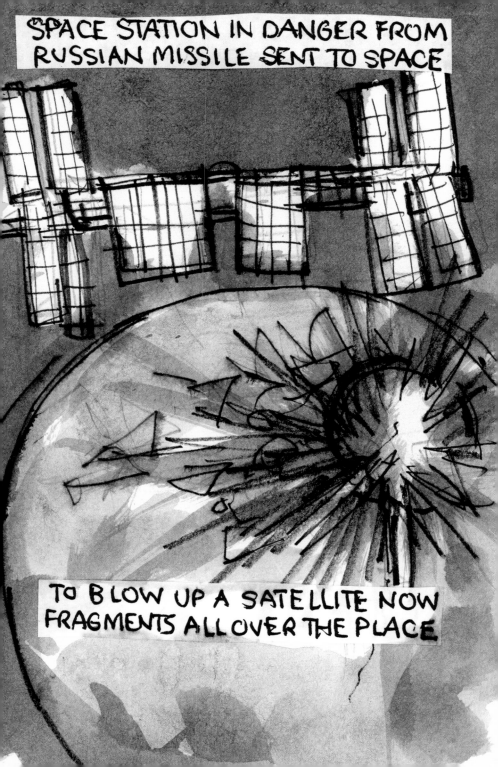

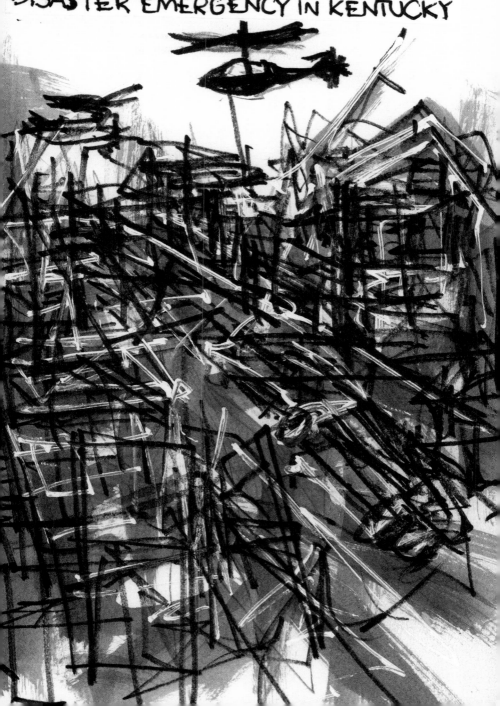

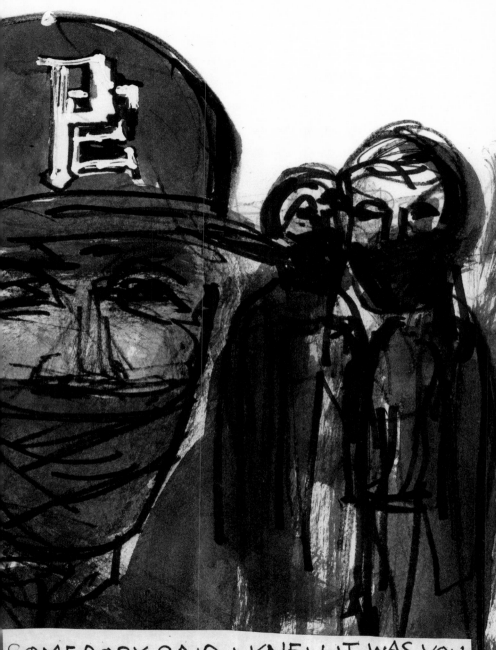

SOMEBODY SAID I KNEW IT WAS YOU
BY YOUR VOICE CHUCK.. MASKED UP
HOODIED OUT DONT MATTER...WTF?

CLIMATE CHANGE CHARGED TORNADOS
AND MIDWEST STORMS ROAMED
THEY SAY MR BEZOS RULES AT
AMAZON WOULDNT LET THEM GO HOME

amazon

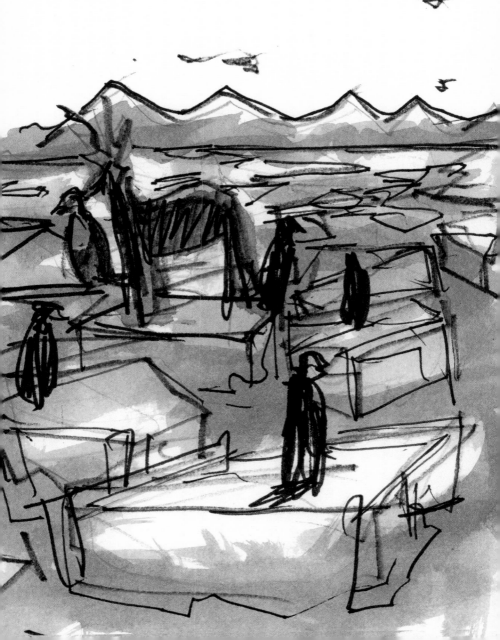

POSING LIKE A ROCK RAP SQUAD
OR A TEAM IN A SPORT, NOW LOOKS
LIKE DC ATTORNEY GENERAL KARL
RACINE IS TAKING THE PROUD BOYS
TO COURT

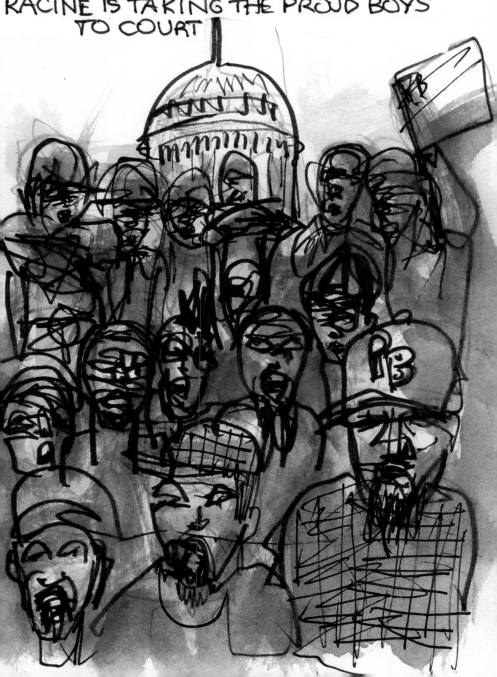

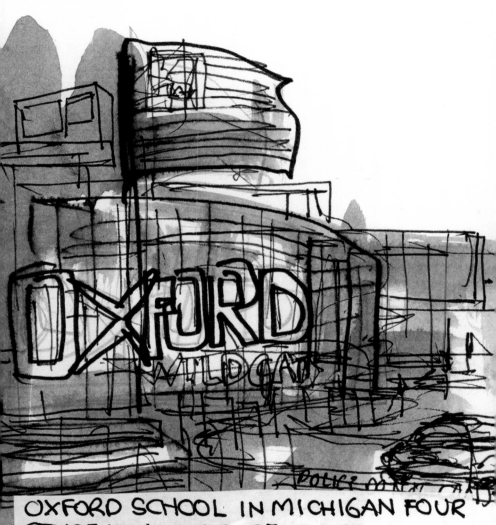

OXFORD SCHOOL IN MICHIGAN FOUR
STUDENTS KILLED, SEVEN PEOPLE
WOUNDED TODAY, THIS SAD TRAGIC
SCHOOL DILEMMA IS BECOMING A
SAME OLD STORY IN THIS USA

SOCIALIZING THROUGH A SCREEN IS THE NOW DATING STYLE, HEAR THE BELL BIV DEVOE MELODY AS YOU CANT TRUSS A MEME AND A PHOTOSHOP SMILE

IT IS A GLORIOUS TRACKING DEVICE

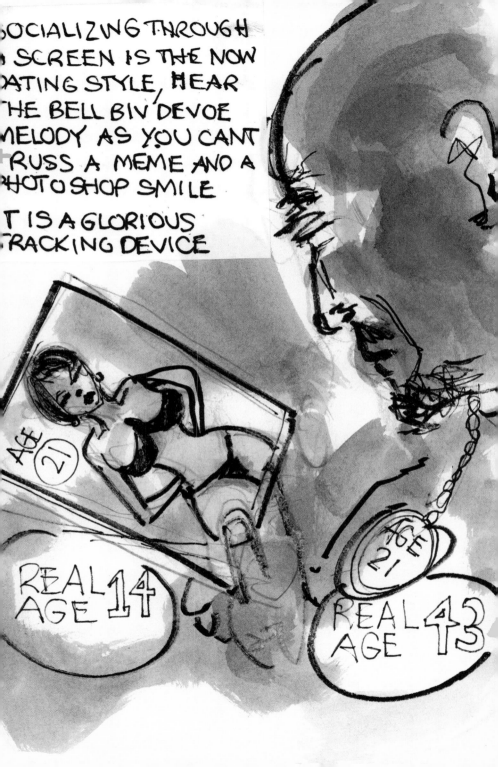

KURTIS BLOW HAS HELPED FOUND
THE HIP HOP ALLIANCE AS THE NEW
UNION TO BE, HE CALLED ME TO
APPEAR WITH ARI M ON MSNBC

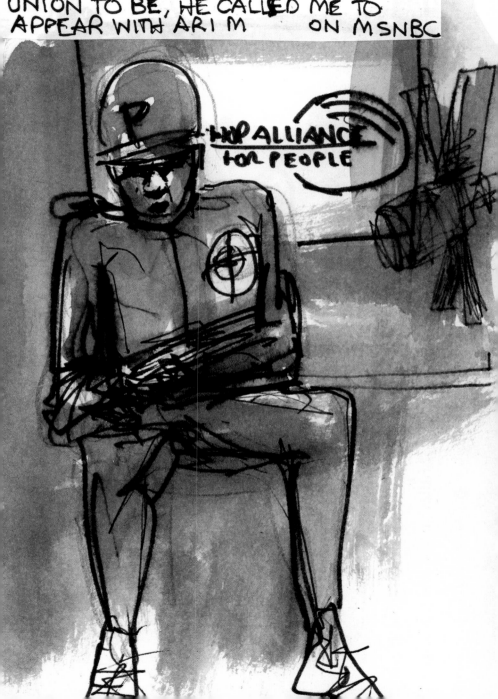

COVID OMICRON IS ATTACKNG PRO SPORT, IN THE NBA TEN BROOKLYN NETS PLAYERS CANT EVEN TOUCH THE COURT

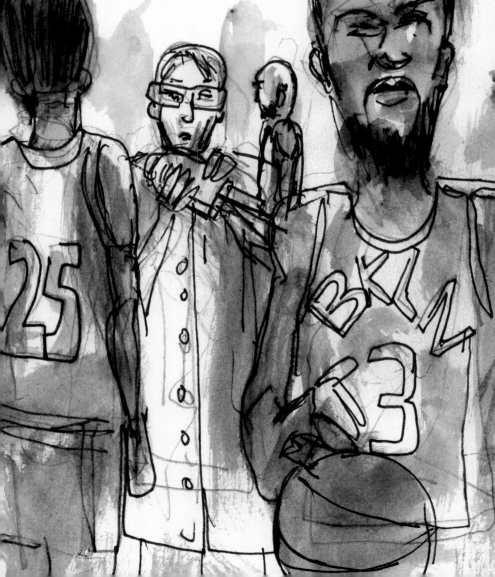

2021 THE GOVERNMENT TOOK A POLL
ON AGNOSTIC LIVIN, NOW A GROWING
NUMBER OF USAERS SAY THEY FOLLOW
NO RELIGION.

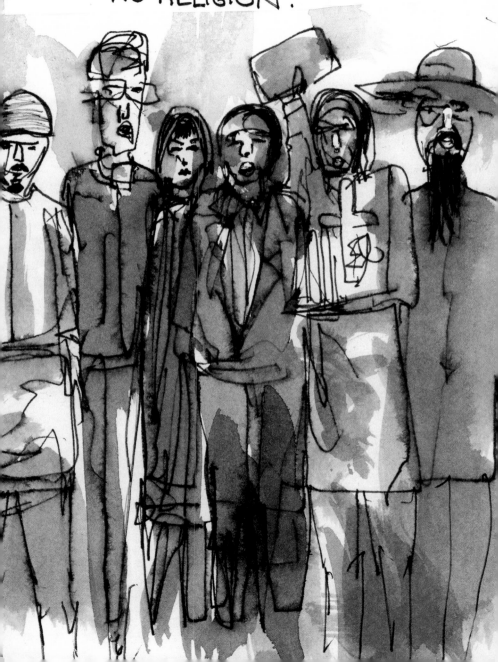

COVID HAS POWER SPREAD IN THE USA NORTHEAST, OMICRON EXPLODED HOLIDAY SEASON YET THE MALLS ARE LOADED

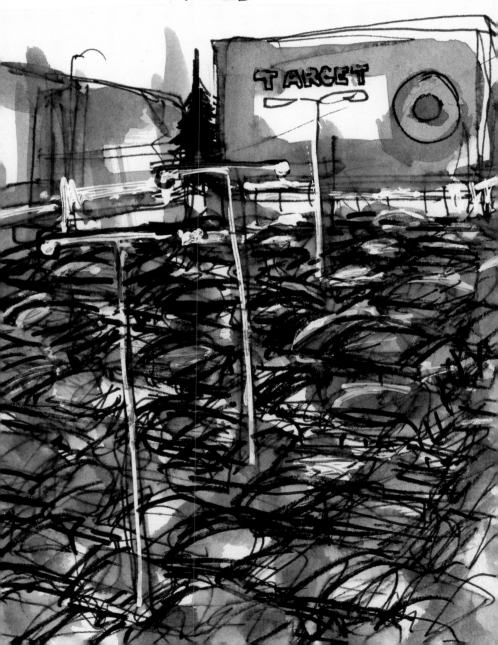

STORES PAD THEIR RETAIL STATS
AS LONG LINES CREATE FROWNS, BUT
MORE AND MORE STRIP MALLS
RESEMBLE GHOST TOWNS

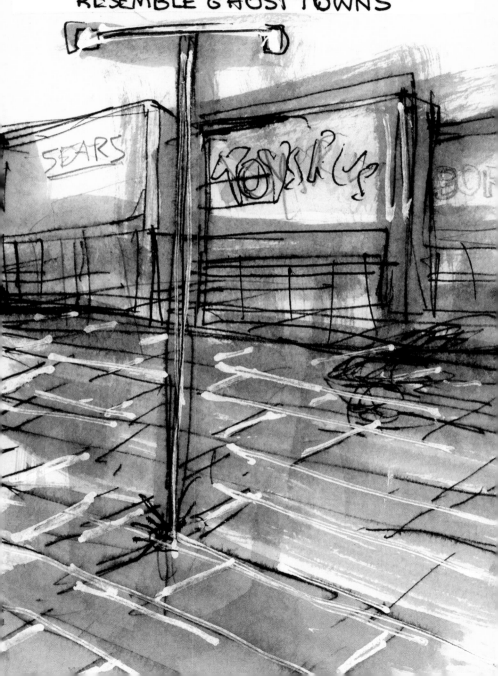

TMZ SAYS FLAV DRIVING THROUGH A CALI CANYON NONSTOP... CAR WAS SMASHED BY A BOULDER ROCK... I CALLED HIM AND HES OK...

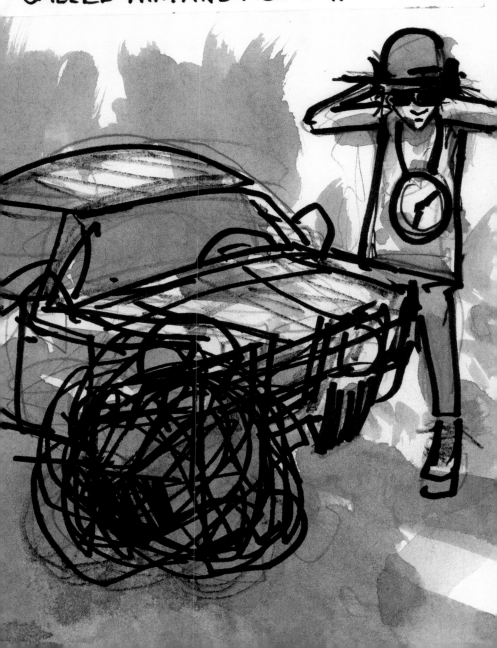

EQUAL RIGHTS FOR EVERYBODY, MEAN MONEY GENDER EQUALITY FOR CRASH TEST DUMMIES?

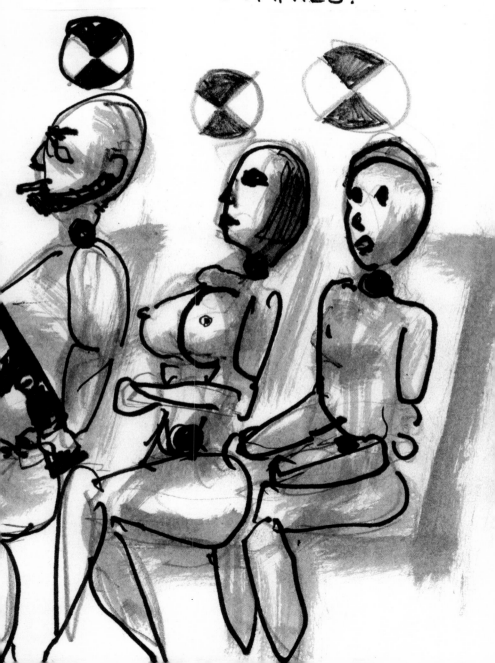

LOST ANOTHER HIP HOP GOD THIS 21
YEAR, ONE OF THE BEST TRULY NICE
GUYS, MC GREAT KANGOL KID UTFO
YES WE SHED ANOTHER TEAR

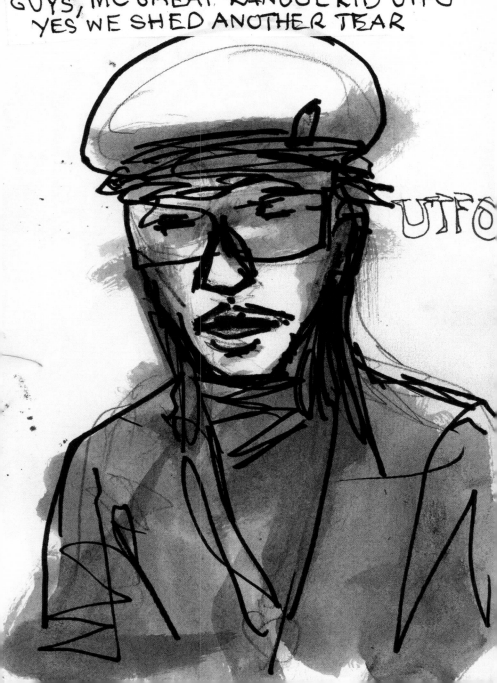

UTFO

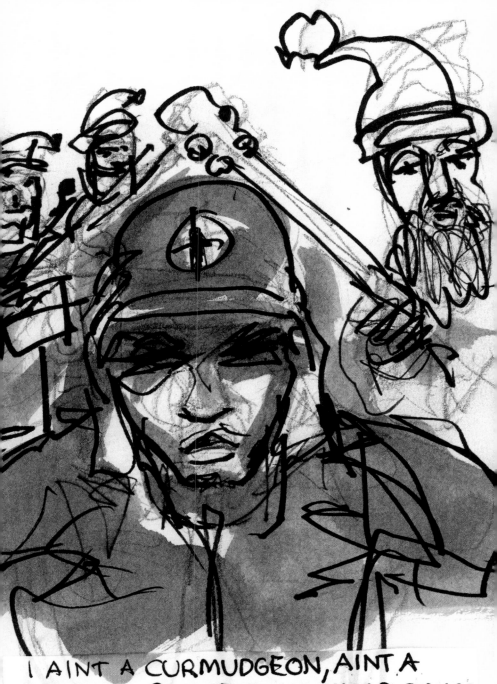

I AINT A CURMUDGEON, AINT A SCROOGE BUT HEARING XMAS SONGS A MONTH AWAY $MASHES MY MOOD

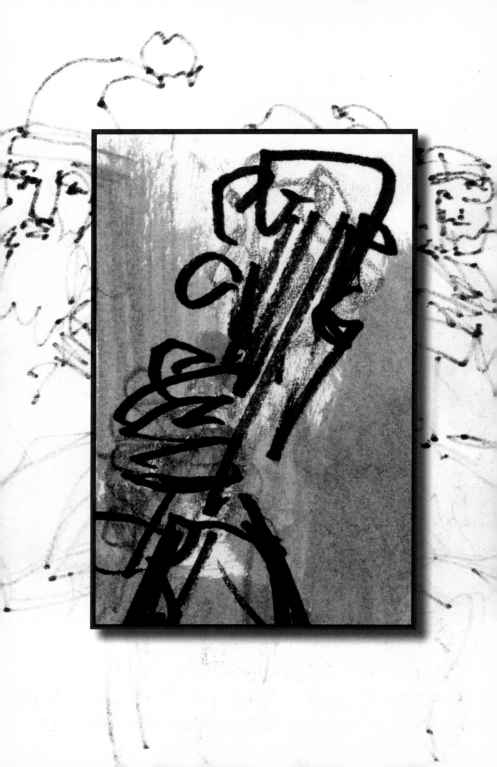

ANOTHER HIP HOP LOSS HITS AGAIN
LEONARD 'HUB' HUBBARD OF THE ROOTS
ONE OF BEST BASSISTS EVER OUT OF PENN

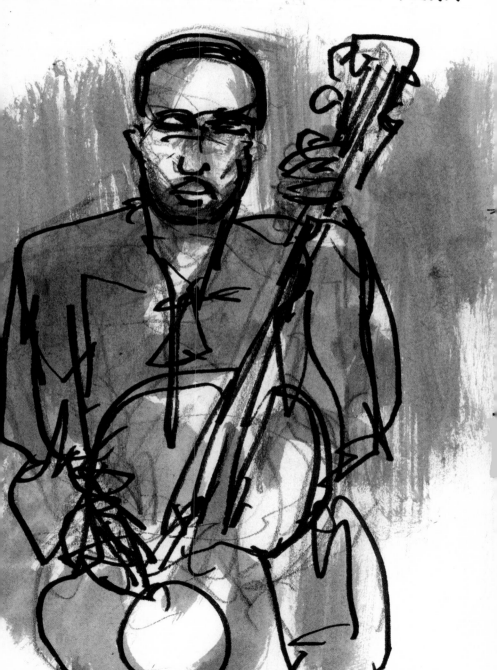

SO KYLE RITTENHOUSE IS NOW A FREE YOUNG MAN, EXCITED INVITED TO SEE THE SUPER BOWL TROPHIES AS A DALLAS COWBOYS FAN...

IF 300 ENTERTAINMENT IS SOLD TO WARNER FOR 500 MILLION, THE QUESTION CULTURALLY REMAINS WITH RECORD LABELS SO WHAT ARE THEY BUILDING? AND FOR WHOM?

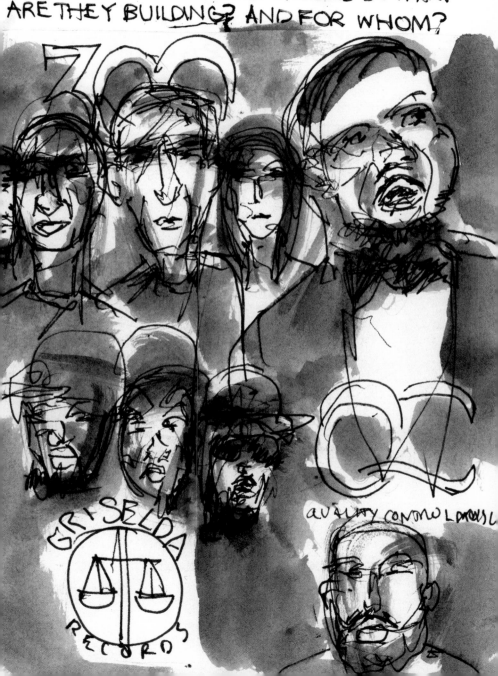

IF THERE'S A FEEL GOOD STORY RIGHT NOW ON MUSIC, ITS 1969 AND ROOTS QUESTLOVE SUMMER OF SOUL WE CAN NOW SEE ON AIRPLANE FLIGHTS AND PRESS A SCREEN TO CHOOSE IT

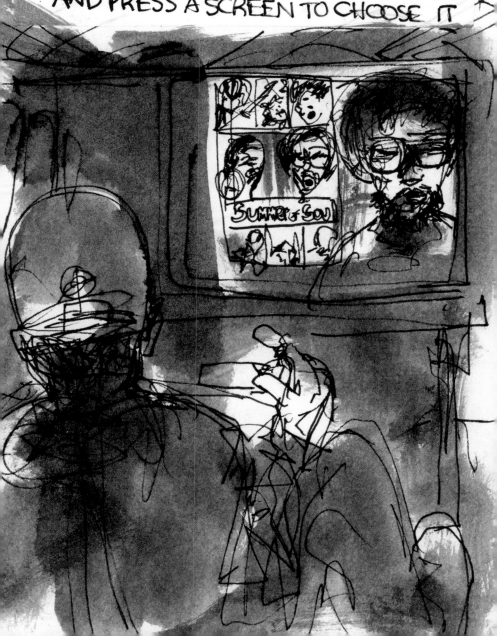

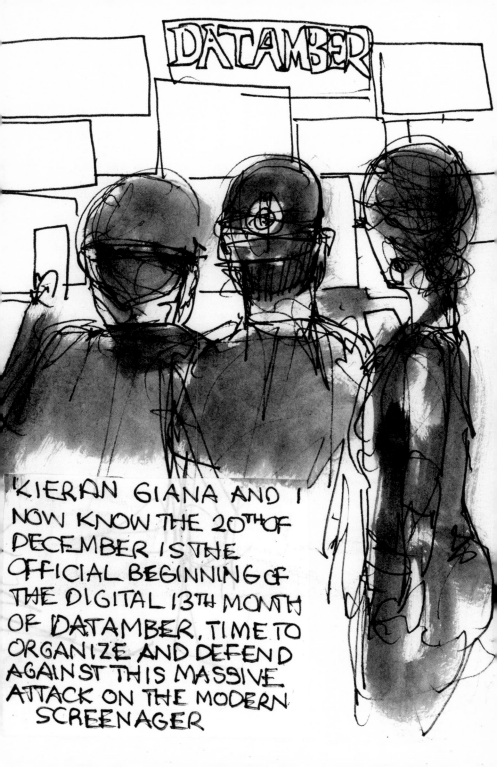

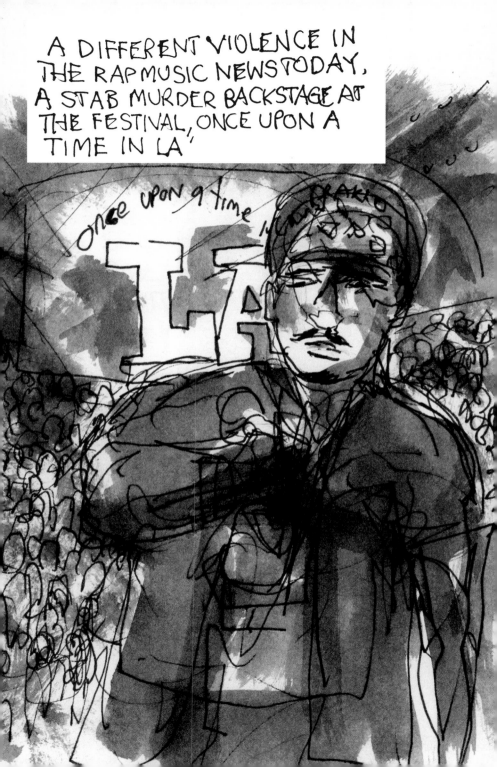

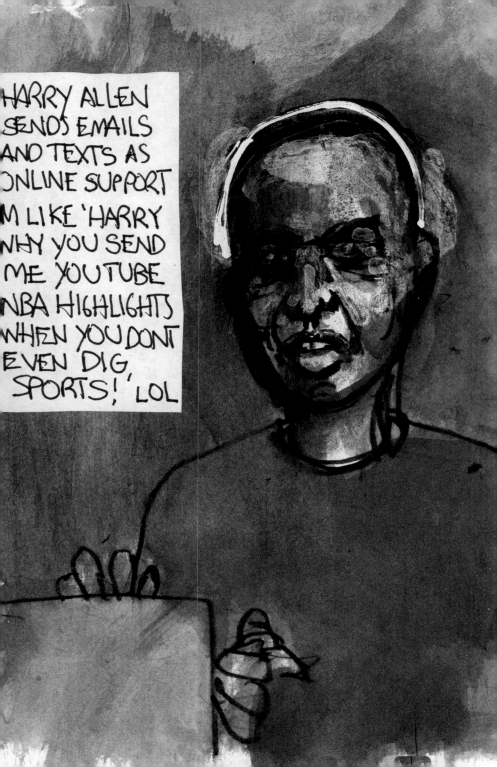

HARRY ALLEN
SENDS EMAILS
AND TEXTS AS
ONLINE SUPPORT

M LIKE 'HARRY
WHY YOU SEND
ME YOUTUBE
NBA HIGHLIGHTS
WHEN YOU DONT
EVEN DIG
SPORTS!' LOL

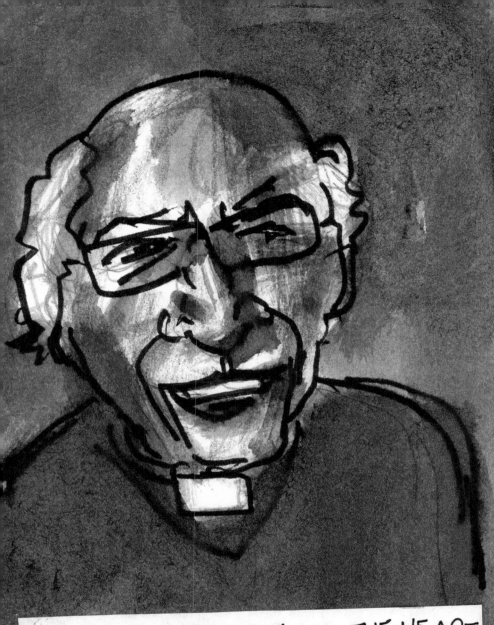

THE GOOD THAT WAS IN THE HEART OF THIS GREAT SOUTH AFRICAN MAN WAS UNDISPUTED, REST IN PEACE. ARCHBISCHOP DESMOND TUTU

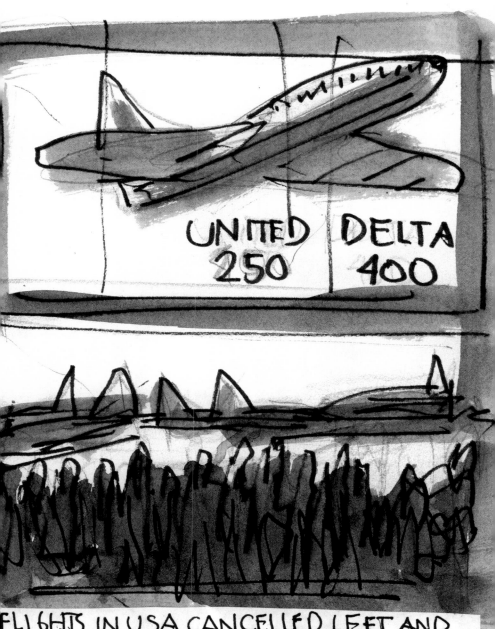

UNITED 250 | DELTA 400

FLIGHTS IN USA CANCELLED LEFT AND
RIGHT, NOT JUST WEATHER RELATED
BUT THIS NEW OMICRON COVID FIGHT

XIAN CHINA A CITY ON TOTAL LOCKDOWN
THIS 2021 THEY AINT PLAYING AROUND

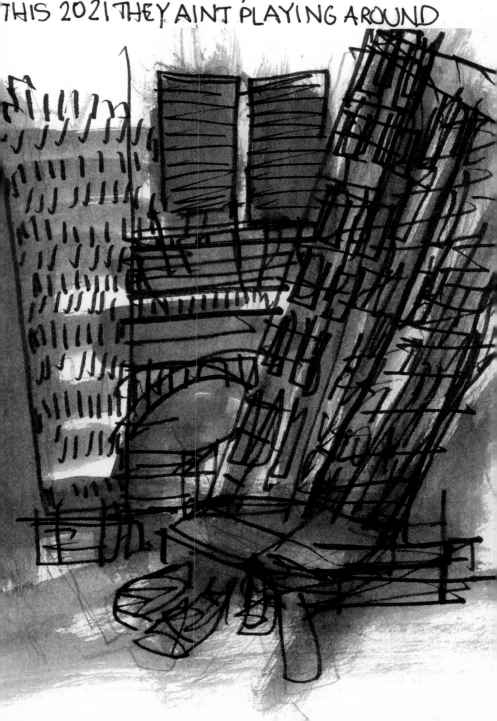

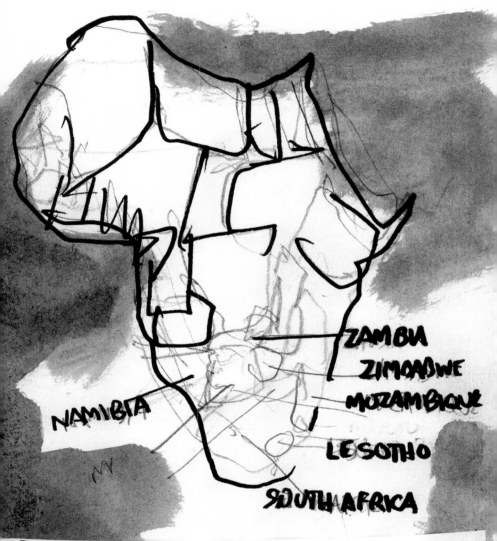

ZAMBIA

ZIMBABWE

MOZAMBIQUE

NAMIBIA

LESOTHO

SOUTH AFRICA

BYE DON LIFTED THE USA BAN ON
8 AFRICAN NATIONS, PARTIALLY
BLAMING SOUTH AFRICA FOR THIS
NEW OMICRON VARIANT CREATION

FLORIDA LIKE MOST PLACES IN
THE SOUTH IS A DRIVE THRU STATE
AND TESTS FOR THIS NEW CO-VID
IS EVEN A LONGER WAIT

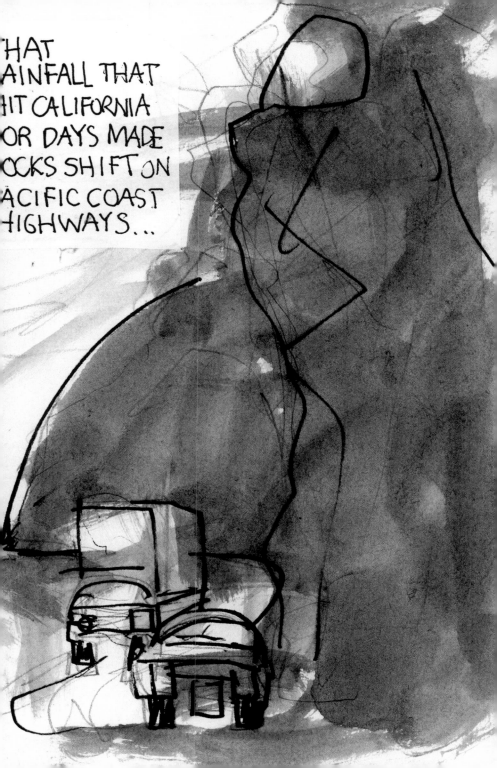

THAT
RAINFALL THAT
HIT CALIFORNIA
FOR DAYS MADE
ROCKS SHIFT ON
PACIFIC COAST
HIGHWAYS...

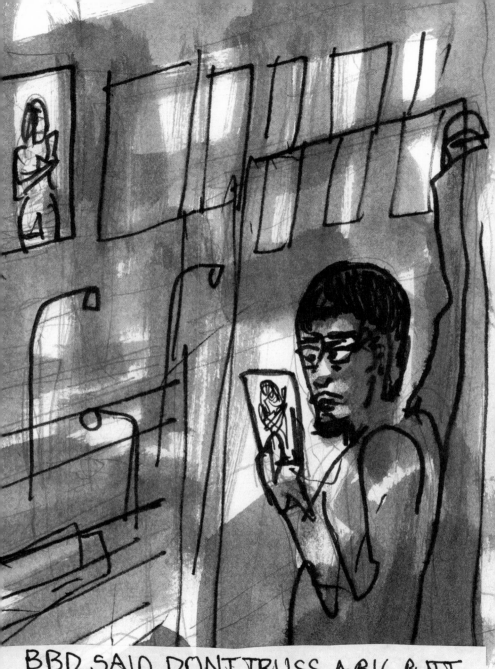

BBD SAID DON'T TRUSS A BIG BUTT AND A SMILE, ADD SCREEN TO IT AND ITS "POISON" SCREENAGER STYLE

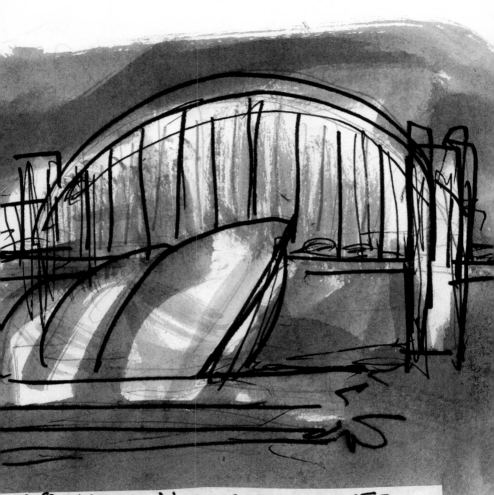

LOCKDOWN OVER CONGRATS
NOW SYDNEY AUSTRALIA OVERRUN
WITH A EXPLOSION OF RATS

PHALLIC SYMBOL AIMED TOWARDS
SPACE LIKE A TUSK, TIME MAGAZINE
MAN OF THE YEAR ELON MUSK

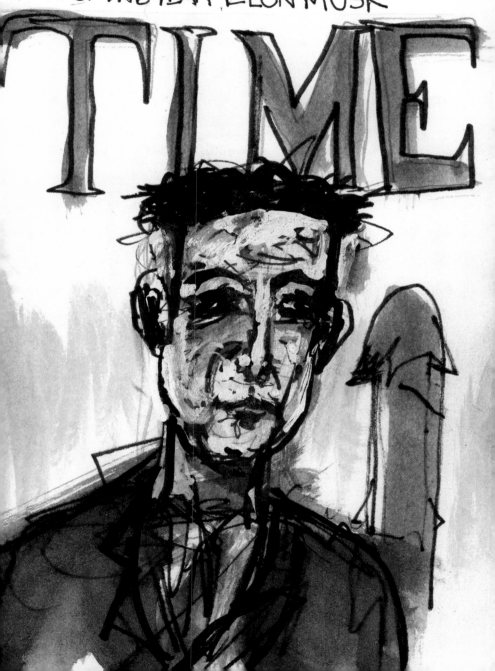

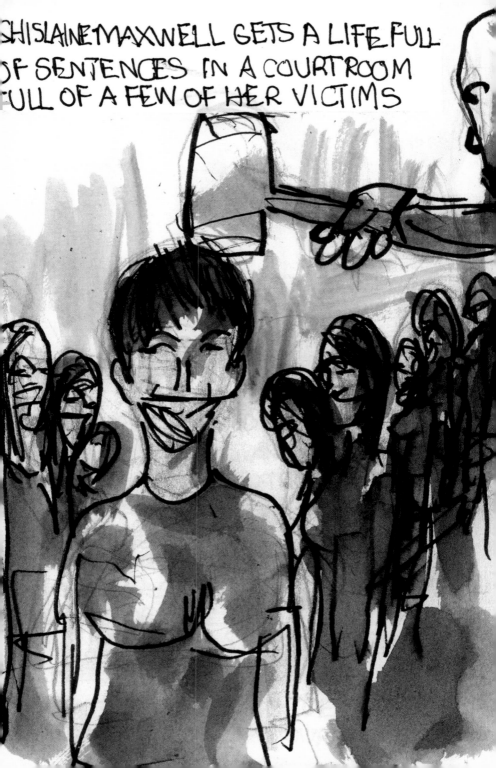

GHISLAINE MAXWELL GETS A LIFE FULL OF SENTENCES IN A COURTROOM FULL OF A FEW OF HER VICTIMS

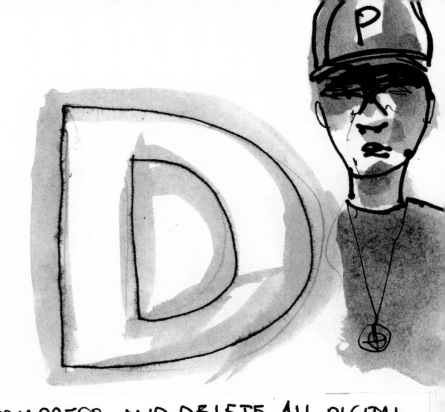

DECOMPRESS AND DELETE ALL DIGITAL
DATA DEMANDS INSTANT ATTENTION FROM
US ALL DUE TO THE EXTREME PERSONAL
RELATIONSHIP WE HAVE WITH OUR DEVICES-
OBJECTS WE HAVE IN OUR POCKETS, HANDS
OR WRISTS 24-7. DEVICES WE ALLOW TO
HAVE COMPLETE CONTROL OF OUR ATTENTION
AND PRIORITISE OVER EVERY OTHER
RELATIONSHIP. A SIMPLE BEEP OR BUZZ
INTERRUPTS EVERY OTHER MOMENT IN OUR
LIVES...

SWITCH OFF EVERY DEVICE FOR A
MINIMUM OF 24 HOURS

AUDIT YOUR ALGORITHMS. AN
ALGORITHM IS ONLY A SET OF
INSTRUCTIONS DESIGNED TO
PERFORM A SPECIFIC TASK.
IDENTIFY THE ALGORITHMS IN
YOUR LIFE AND TAKE ACTION
AGAINST THOSE THAT ARE
WORKING FOR THE BENEFIT OF
OTHERS AND NOT FOR YOUR LIFE.

TAME YOUR TERA'S: BYTES AND
FLOPS. YES, THERE IS AN
APPLICATION FOR EVERYTHING. BUT
HOW MANY DO YOU NEED? HOW MANY
ACTUALLY HELP OR HINDER YOUR
COGNITIVE STRENGTH. REVIEW AND
REDUCE THE APPS YOU RELY ON. EVERY
APP YOU HAVE SHOULD ONLY PERFORM A
TASK THAT IMPROVES YOUR LIFE.

APPLICATIONS AND ATTITUDE.
ASSESS HOW YOU PROTECT
YOURSELF, EVERYTHING FROM
THE SOFTWARE YOU USE HOW
OFTEN ITS UPDATED AND HOW
OFTEN YOU TAKE RESPONSIBILITY
FOR PROTECTING AND BACKING
UP YOUR DATA.

MEMORY MANAGEMENT, DECIDE WHAT DATE IS IMPORTANT TO YOU AND TAKE RESPONSIBILITY FOR STORING AND SAFEGUARDING IT. WE ARE NOW IN A AGE WHERE WE'LL NEVER RUN OUT OF DIGITAL MEMORY · ONLY MENTAL MEMORY

BINARY BANDWIDTH DECIDE
WHEN AND HOW YOU WANT TO
USE AND ENGAGE WITH YOUR
DEVICES AND APPLICATIONS.
THEY ARE TO BE USED BUT NEVER
RELIED ON. BACK UP EVERYTHING
YOU NEED AND CARE ABOUT

EQUALISE YOUR ECHO CHAMBERS
ALGORITHS ARE DESIGNED TO GIVE
YOU MORE OF WHAT IT THINKS YOU
WANT, LIKE AND THINK, IF YOU GOOGLE
'DOG FOOD' THEN FOR WEEKS ALL YOUR
SOCIAL CHANNELS WILL SUDDENLY BE
SHOWING YOU MORE AND MORE DOG
PRODUCTS. THE SAME HAPPENS WITH
YUUR OPINIONS, THE ALGORITHM WILL
EXPOSE YOU TO MORE AND MORE CONTENT
IT THINKS YOU WILL ENGAGE IN AND
SURROUNDING YOU WITH OPINIONS IT
THINKS YOU BELIEVE THAT LEADS YOU
LIVING IN A ECHO CHAMBER THAT
ENTRENCHES OPINIONS

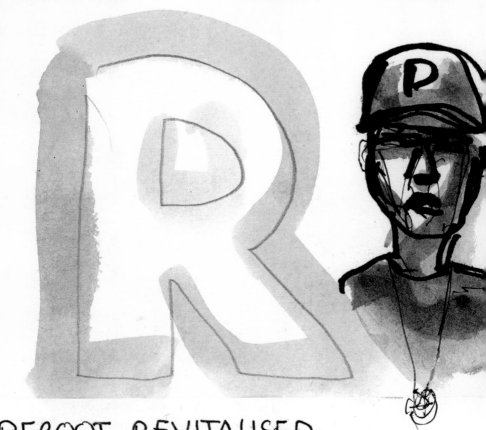

REBOOT - REVITALISED

THIS IS A PERIOD TO RENEW, AN
OPPORTUNITY TO REFRESH AND
REFOCUS, RELEASE YOURSELF FROM
THE PRESSURE OF FEELING TRAPPED
BY THE FEELING OF NEEDING TO
CONSUME. YOUR GOALS ARE CLEAR AND
THE DIGITAL TOOL BOX YOU HAVE IN YOUR
POCKET WILL ASSIST YOU IN

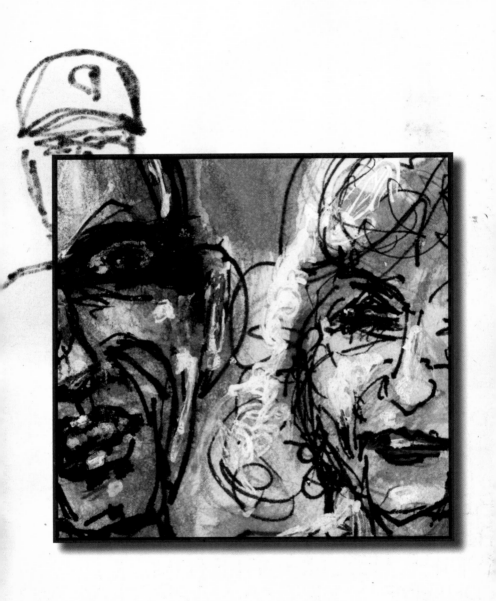

I WAS IN A STORE, BETTY WHITE WAS ON A COVER AND THE SUBJECT OF HER TURNING 100 AROSE, NOW WE GET THE SUDDEN NEWS OF HER PASSING, THE LAST DAY OF 2021

ALONG WITH BOSTON CELTIC GREAT SAM JONES. THE BANK IS CLOSED...

TORNADO FIRES RIPPING THROUGH
BOULDER COLORADO, MANY THOUGHT
THAT THIS WAS ARMEGGEDON...

FROM BURYING DAVIDSON IN A VIDEO
TO SELLING STEM PLAYERS FOR 200,
FOLKS SAYIN THERES A SCREW MISSIN
AT THE SAME TIME MILLIONS FOLLOW
HIS MIND, YE IS A MILLENIAL RELIGION

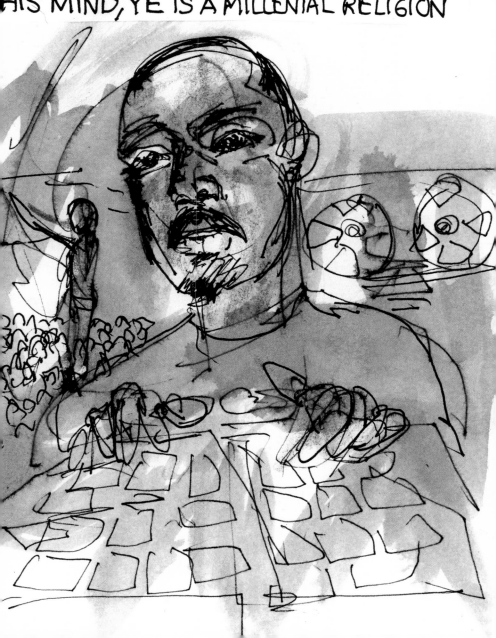

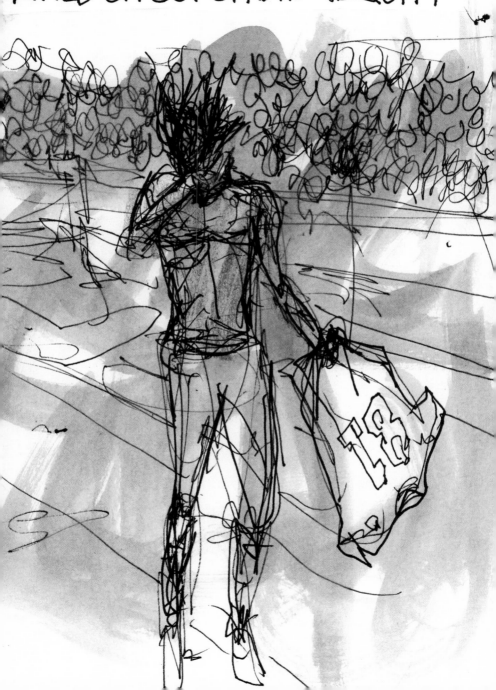

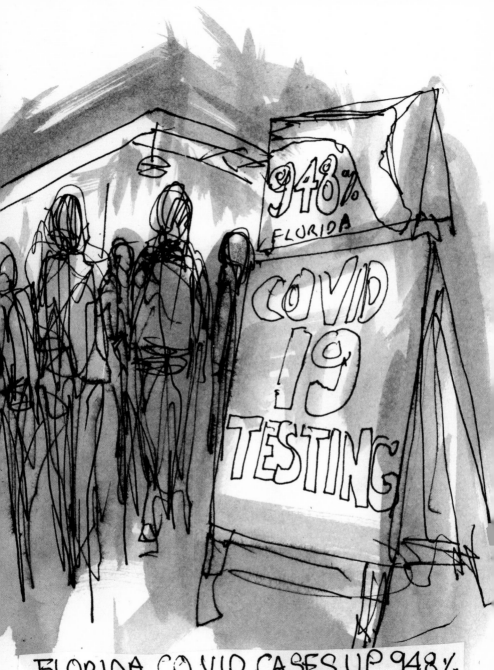

FLORIDA COVID CASES UP 948%.
IMPOSSIBLE NUMBERS WITH LINES A
HALF MILE OUT OF TESTING TENTS

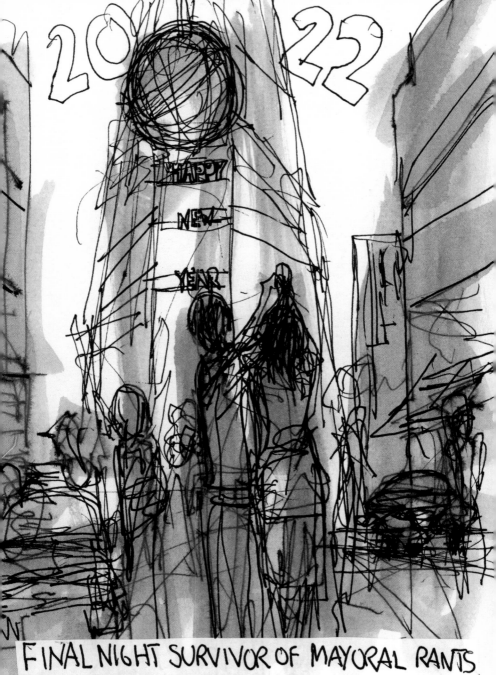

FINAL NIGHT SURVIVOR OF MAYORAL RANTS
NEWYEARS EVE THE DE BLASIOS DO A
FAREWELL LAST DANCE ...

INSURRECTION DAY JAN 6TH BYEDON AND
KAMALA PUSH THE ISSUE OF THE CRIME

GREEN EGGS AND INGRAHAM HANNITY
PLEAD INSANITY WHILE TRUMP KIDS
JUNIOR AND IVANKA REFUSE TO TESTIFY

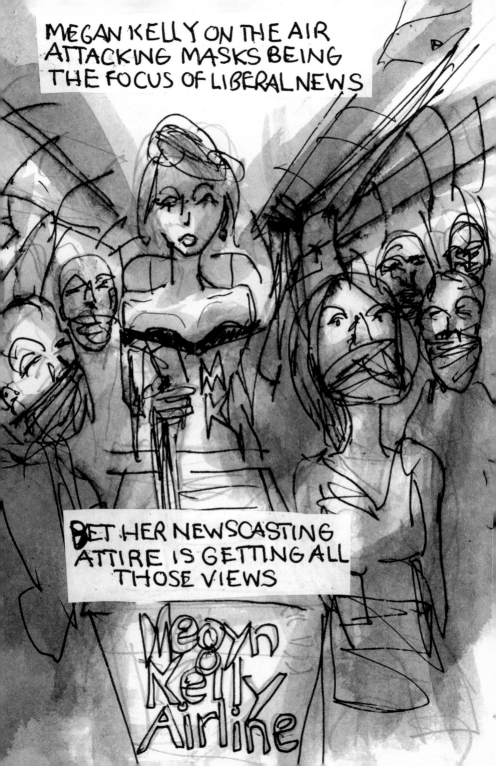

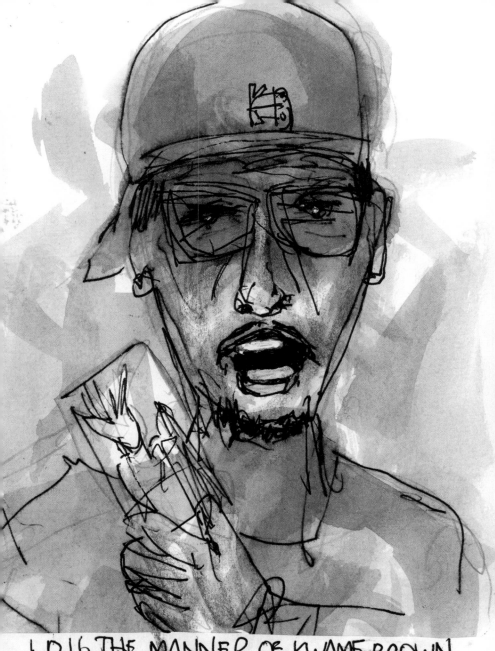

I DIG THE MANNER OF KWAME BROWN
HE SAW A FLAW IN WHAT HE POSTED AND
WAS LIKE 'MY BAD AND APOLOGIZED TO
ANTONIO BROWN FOR HIS COMMENTS

ALWAYS BEEN A SPORTS
FAN AND WILL NOT STOP,
WATCHED AS A NEW
YORKER WITH MY POPS
BEFORE HIP HOP, NOW
SOCIAL MEDIA BRINGS
THE NOISE WITH UP
AND COMING HOSTS LIKE
CP. HES THE FANCHISE
INVITING FAN VOICES
ON KNICKS FANTV.

KFTV

NYK

- KNICKS FANTV
- CP THE FANCHISE
- TRATICASTERIO1
- THE KOT SHOW
- NOTHIN BUT KNICKS
- KNICK FILM SCHOOL
- JD SPORTSTALK NY
- ASHNICOLE MOSS
- _CK2K

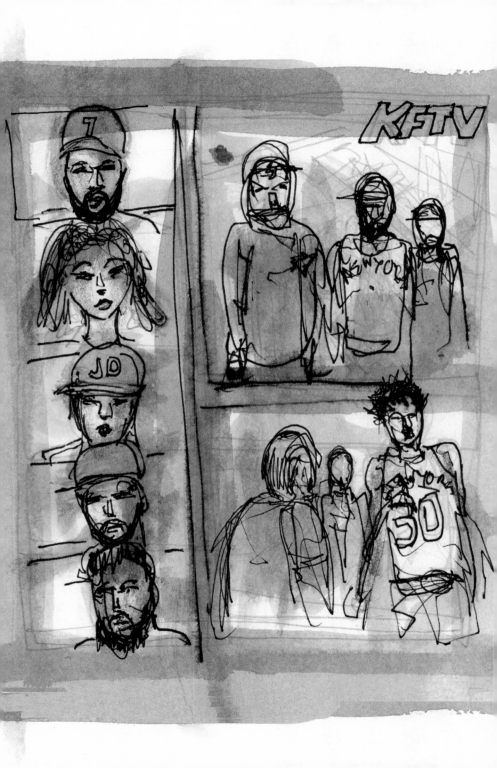

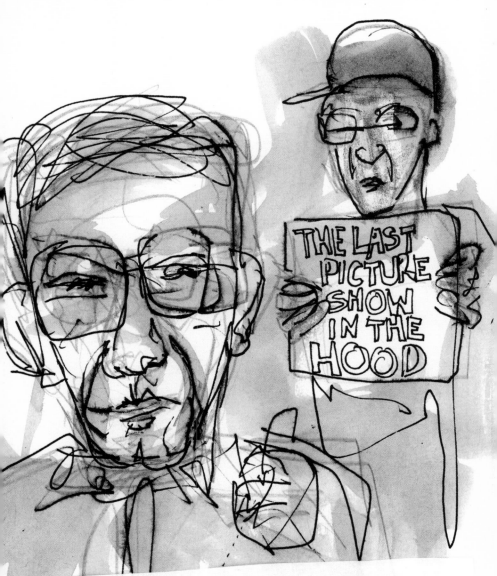

JUST 2 WEEKS AGO I WATCHED THE
LAST PICTURE SHOW FOR THE FIRST
TIME NOW TODAY PETER BOGDANOVICH
PASSES AWAY, COINCEDENTALLY ON WHAT
WOULD'VE BEEN JOHN SINGLETONS 55TH BIRTHDAY

YET ANOTHER TRANSITION, BROTHER
JESSIE D OF THE FORCE MDS REST IN BEATS

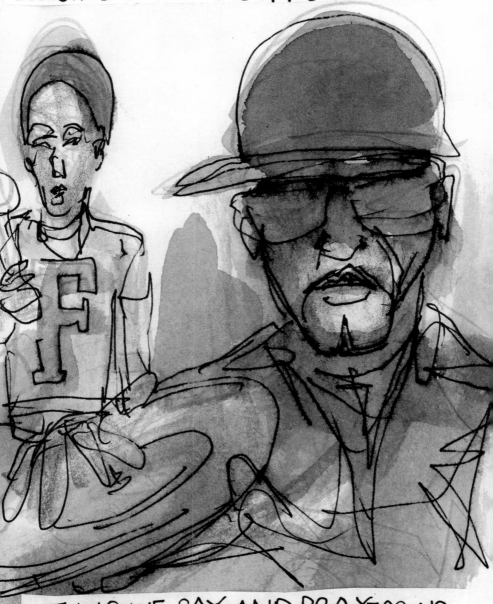

THUS WE SAY AND PRAYERS UP
GET WELL TO HIP HOP GOD DJ KAY SLAY

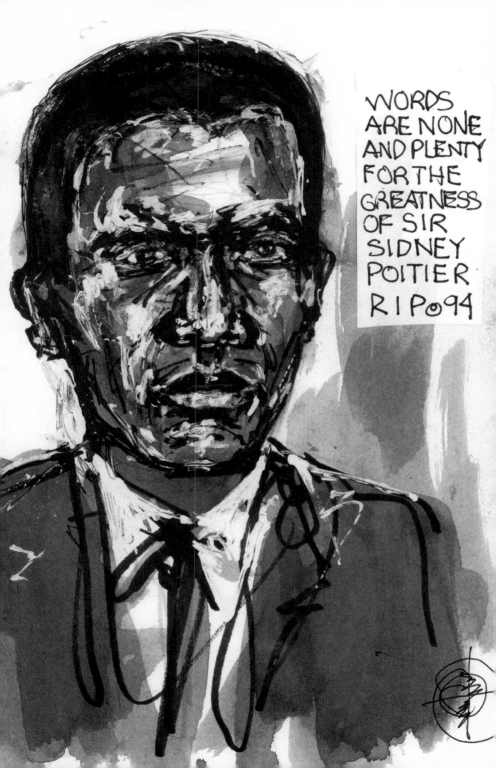

WORDS ARE NONE AND PLENTY FOR THE GREATNESS OF SIR SIDNEY POITIER RIP ©94

MORE SCREENAGER SICKNESS IF NOT THE WOMAN WHO WAS SELLING HER FARTS IN A JAR BUT THOSE FANS THAT BOUGHT THEM WERE THE MORE BIZARRE...

AHMAUD ARBERY IS NOT COMING BACK, INTO THIS LIFE, THUS ITS ONLY RIGHT THESE 3 PAY THEIR TIME BACK WITH LIFE

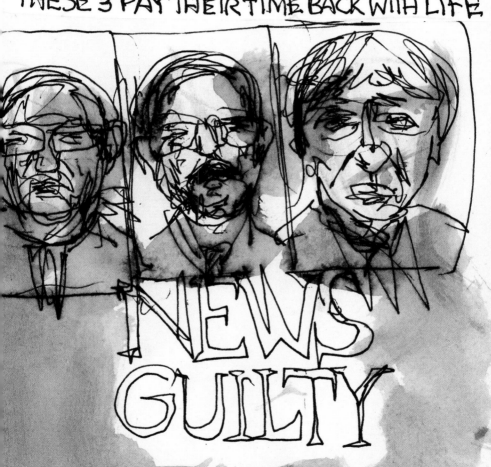

JAMES MTUME WAS SO MUCH MORE
THAN 'JUICY' HE WAS A SAGE FOR
YEARS HE FOUGHT FOR MUSIC THE
LIBERATION OF MINDS BODYS AND SOULS
ON THE RADIO ALONGSIDE BOB SLADE

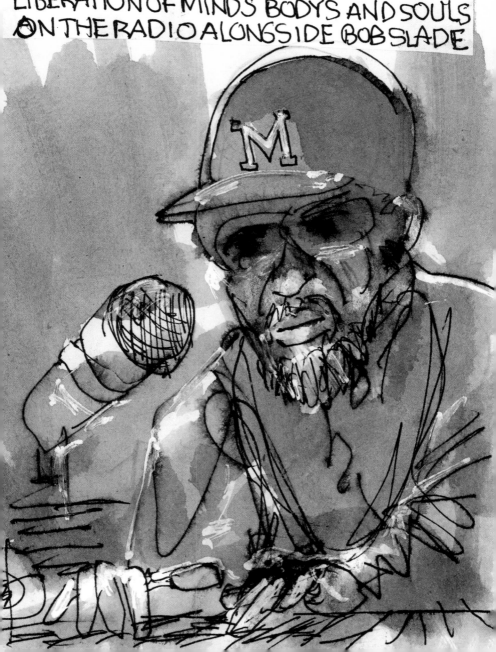

FIRST WOMAN MANAGER IN BASEBALL
PROFESSIONAL HISTORY SALUTES TO
RACHEL BALKOVIC OF THE TAMPA
TARPONS CLASS A TEAM OF THE YANKEES

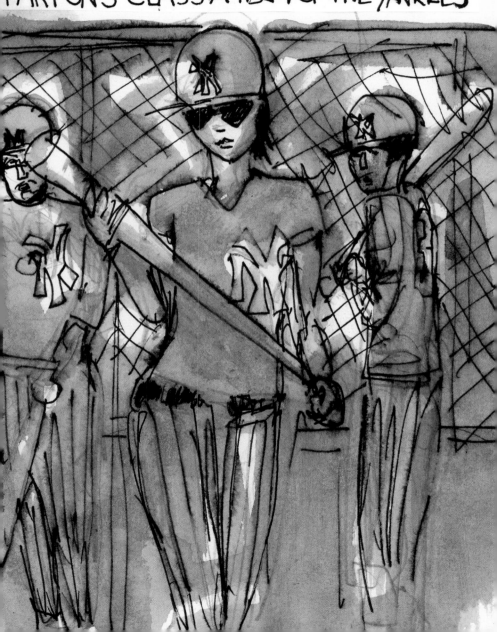

SEEMS LIKE A LOT OF PEOPLE WILL NEVER FORGET THE HUMOR AND GOOD NATURE OF BOB SAGAT

IN THE MIDDLE OF NIGHT I WAS
ANSWERING TWITTER DMS THEN
I GOT LOCKED OUT AND I JUST
COULDNT LOG THE HELL BACK IN

WHAT WENT WRONG, WHO WHAT
WHEN AND WHY AS I THOUGHT BACK
THEN I REALISED I WASN'T ALONE
IN THIS SOC MED ATTACK

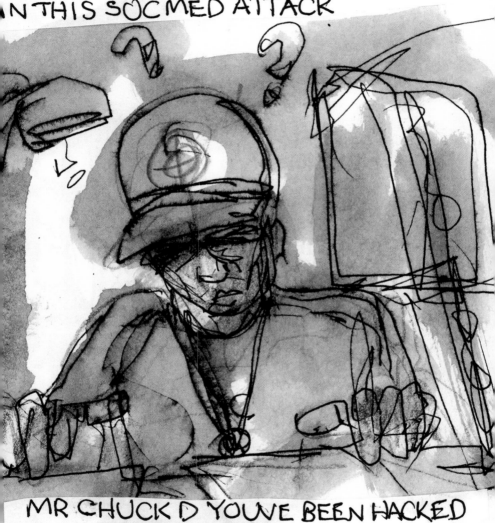

MR CHUCK D YOU'VE BEEN HACKED

 TWEETS AREN'T LOADING RIGHT NOW

 FIND YOUR TWITTER ACCOUNT

ERROR, WE COULD NOT FIND YOUR ACCOUNT

 MY SHOE PLUG, WANTED TO ASK WOULD YOU BE INTERESTED IN BEING A MODEL BRAND AMBASSADOR FOR... IN EXCHANGE

HEY MAN, I THINK YOUR TWITTER WAS HACKED?

HACKED, SHT.

 PEACE OG, ELITE SENT ME THIS. I DONT THINK IT WAS YOU...

YEAH, ITS UGLY

YOU NEED TO POST A VIDEO SAYING YOUR TWITTER WAS HACKED

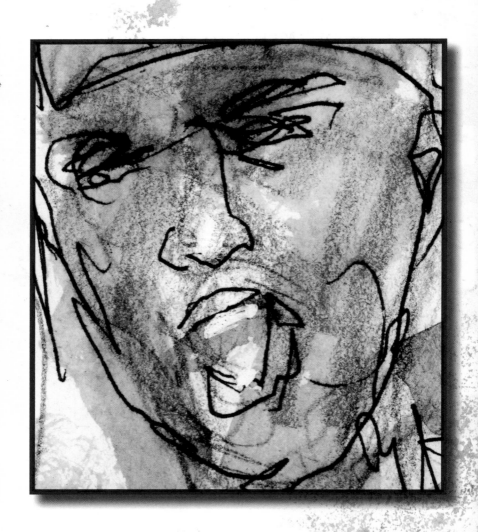

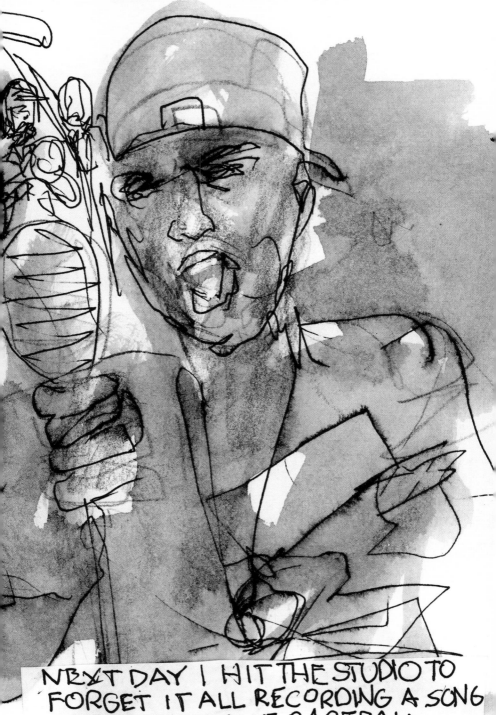

NEXT DAY I HIT THE STUDIO TO FORGET IT ALL RECORDING A SONG FOR MAJOR LEAGUE BASEBALL

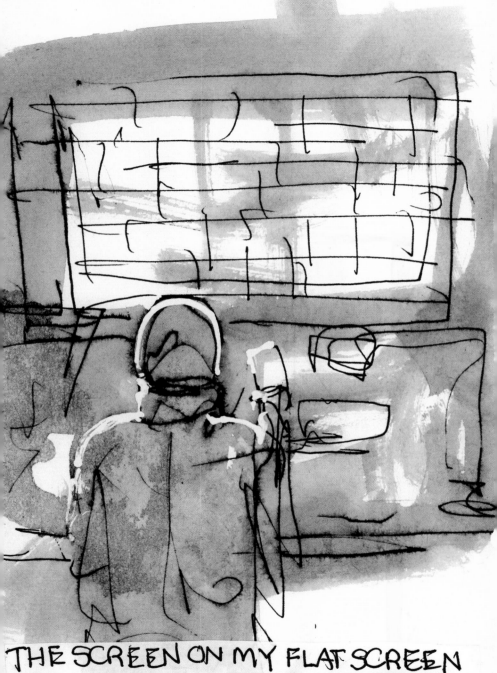

THE SCREEN ON MY FLAT SCREEN
GOT MORE AND MORE MINI SCREENS
CALLED APPS CONFUSING ME

IS IT ME OR MY IMAGINATION, BUT I
SEE KEV HART, SNOOP AND SHAQ,
SELLING EVERY BRAND IN THE NATION

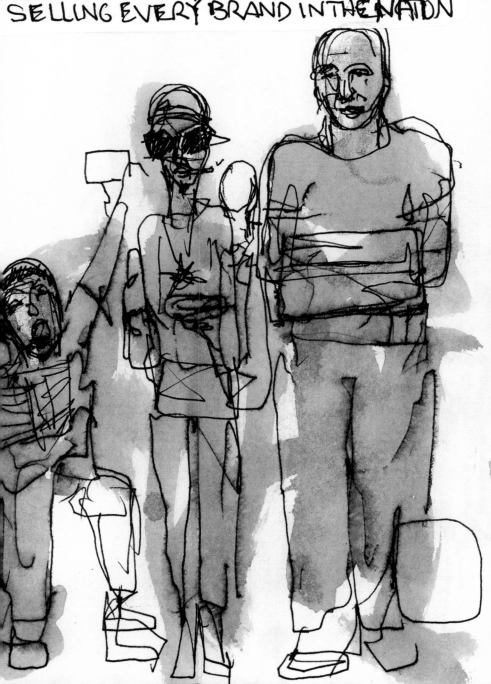

RESPECT, REST IN PEACE TO THE GREAT RONNIE SPECTOR PASSING AT 78

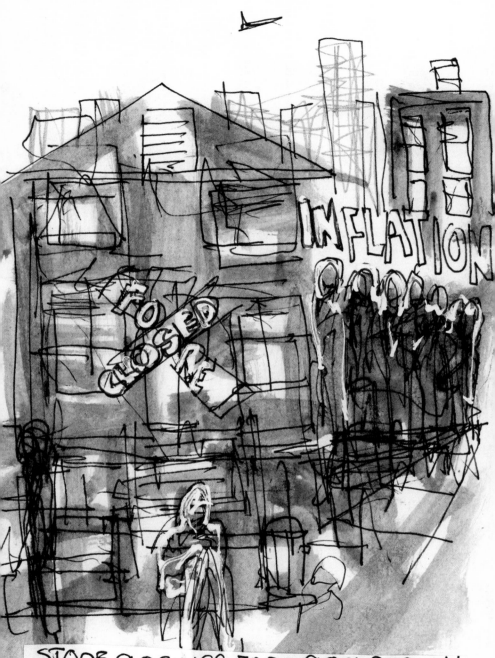

STORE CLOSINGS FORECLOSURES ALL OVER WHILE INFLATION RISES TO CRUSH ECONOMY LIKE A BOULDER

BANKS SNATCHING MORTGAGES
BACK, YET BANKERS YEAR END
OWN ACCOUNTS STAY SWOLLEN, FAT

2022
MR BANKS
+
$12,656,238
personal

THERE ARE FEW WORDS FOR THE
LOST IN A BRONX FIRE OF
THEM CHILDREN AND THE LANDLORDS
AND THE LAW HAVE BEEN QUIET

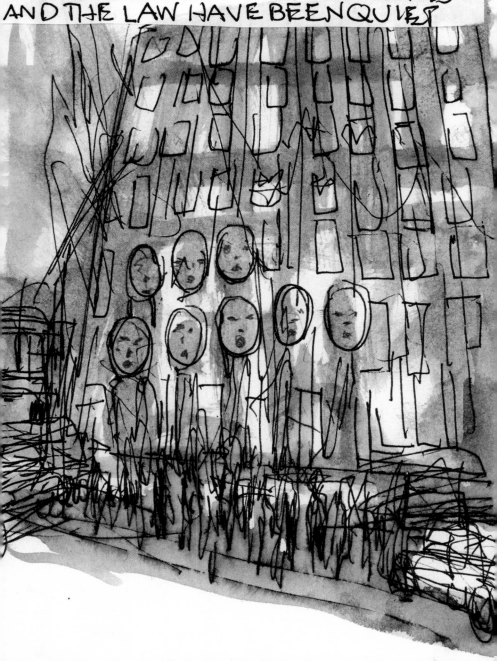

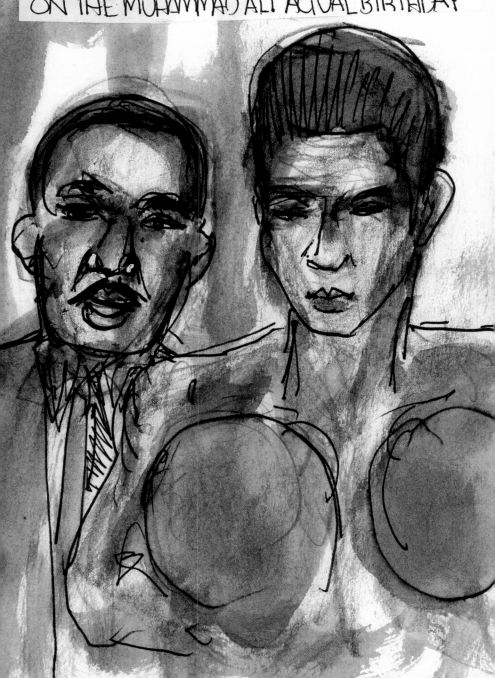

THE HOLIDAY FOR DR MARTIN LUTHER KING IS TODAY FALLING COINCEDENTALLY ON THE MUHAMMAD ALI ACTUAL BIRTHDAY

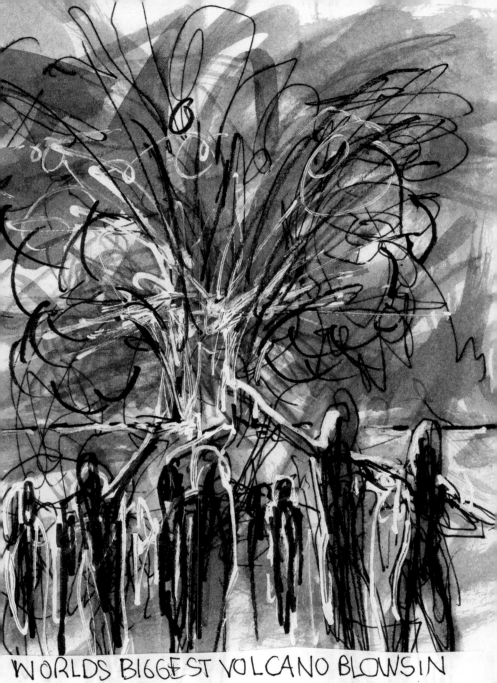

WORLDS BIGGEST VOLCANO BLOWS IN
THE TONGAN PACIFIC, TSUNAMI
ALERTS ON THE RING OF FIRE SPECIFIC

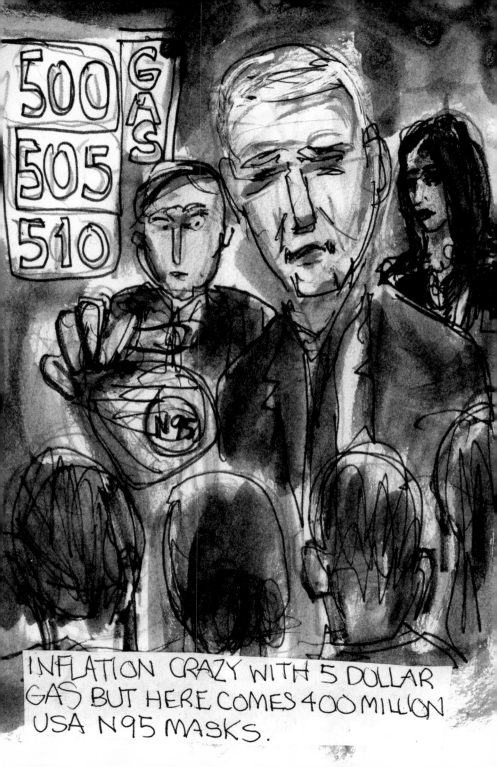

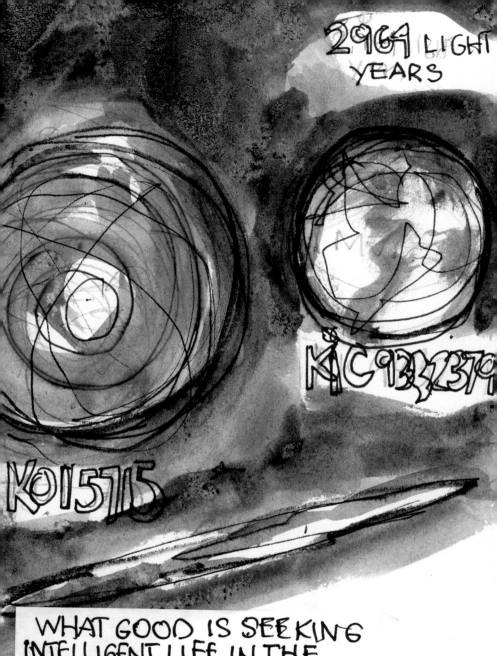

MAYA ANGELOU IS NOW ON A USA
QUARTER, SUCH A BIG DEAL, STILL;
BUT I AINT SEEN HARRIET TUBMAN
YET ON A UNITED STATES 20 DOLLAR
BILL

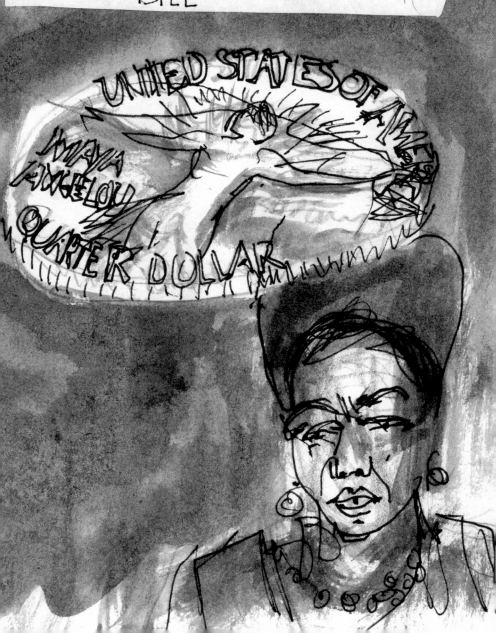

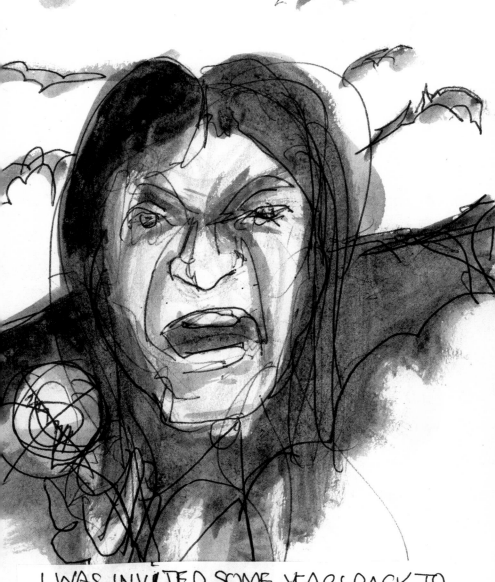

I WAS INVITED SOME YEARS BACK TO
DO A COLLAB SONG CALLED MADMAD
WORLD/THE GOOD GOD IS A WOMAN AND
SHE DONT LIKE UGLY, WITH MEATLOAF
BY HIS SON IN LAW SCOTT IAN OF ANTHRAX
I THANK THEM BOTH -- REST IN BEATS

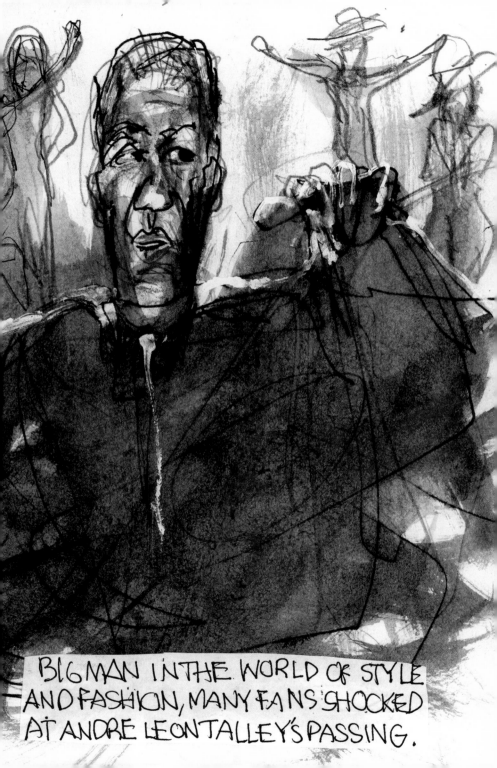

BIG MAN IN THE WORLD OF STYLE AND FASHION, MANY FANS SHOCKED AT ANDRE LEON TALLEY'S PASSING.

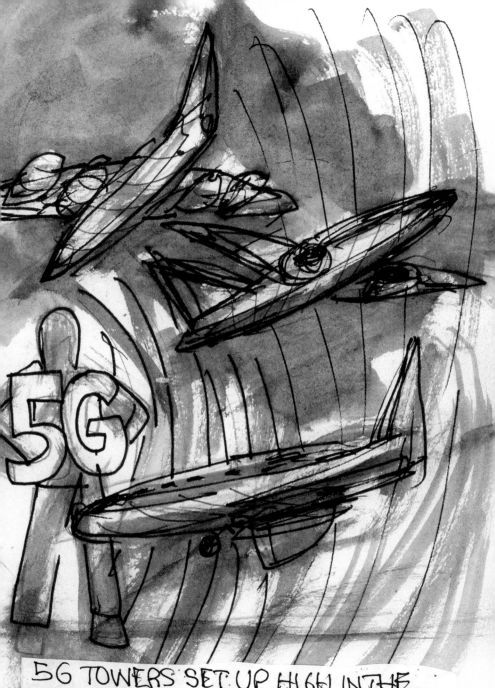

5G TOWERS SET UP HIGH IN THE
2022 NIGHT BUT 5G NEAR AIRPORTS
ARE REPORTED TO MESS WITH FLIGHTS

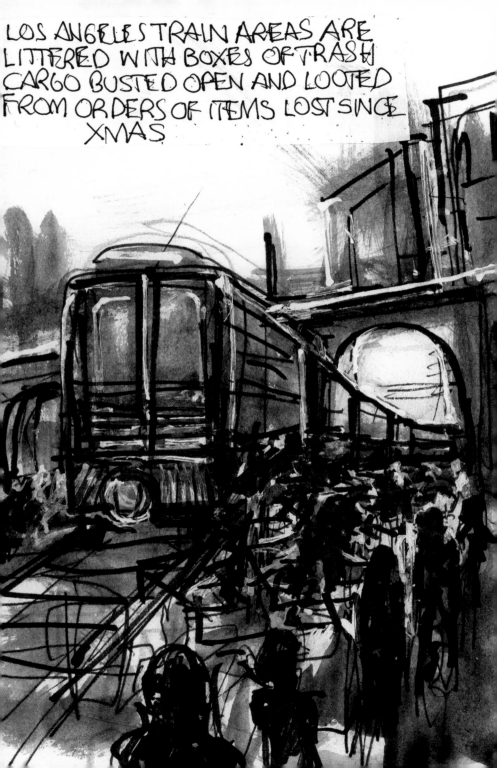

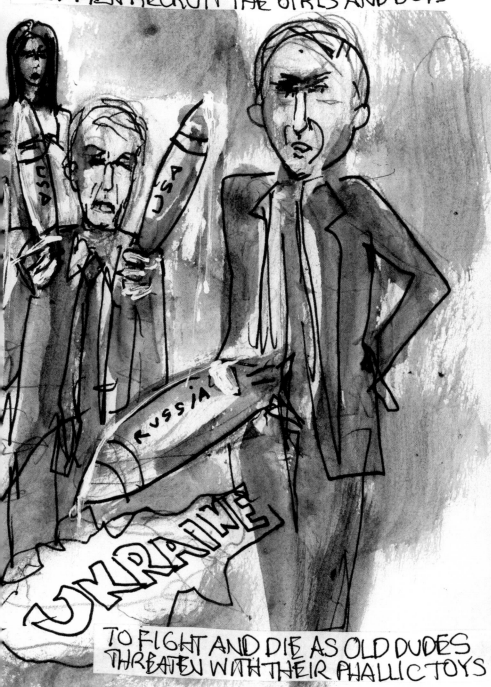

GUNS GUNS GUNS, EVERYWHERE IN NYC MAYOR ERIC ADAMS VOWS TO CHANGE THIS AS THE LATEST CASULTIES ARE 2 POLICE MURDERED FROM A DUDE. WITH A PRIOR RECORD AND FELONIES

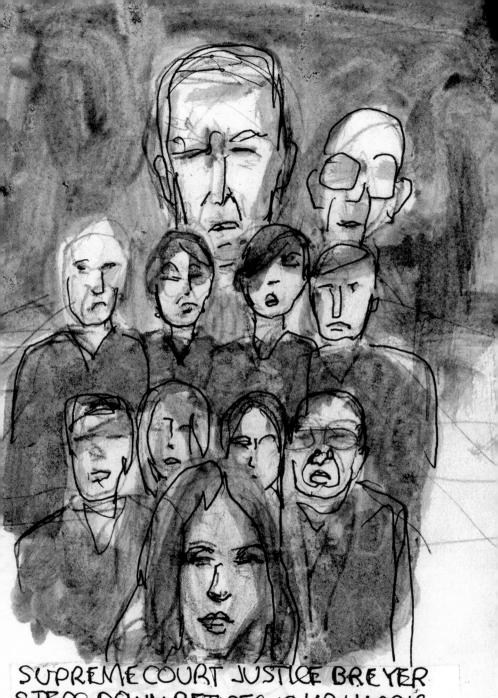

SUPREME COURT JUSTICE BREYER
STEPS DOWN RETIRES, IS VP HARRIS
A PICK, HEARD RUMOR ON THE WIRE?

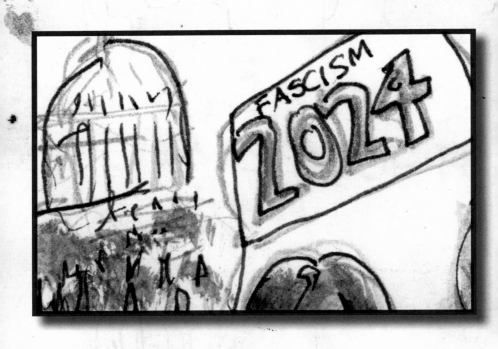

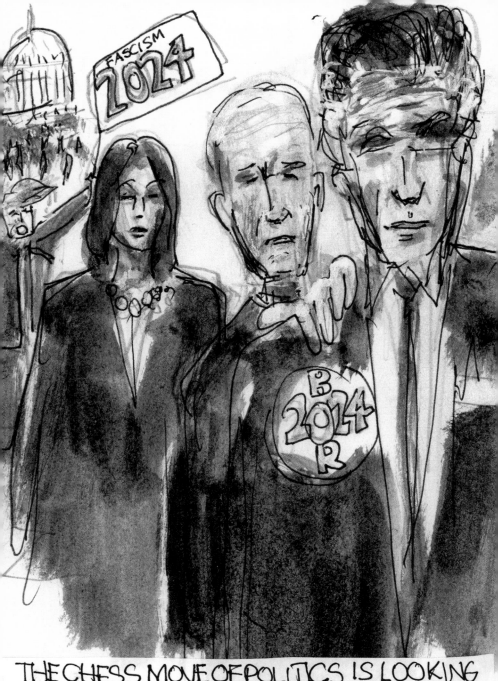

THE CHESS MOVE OF POLITICS IS LOOKING LIKE THIS BYEDON TAPPING MITT ROMNEY MAKES GOP GO WHAT IS THIS??

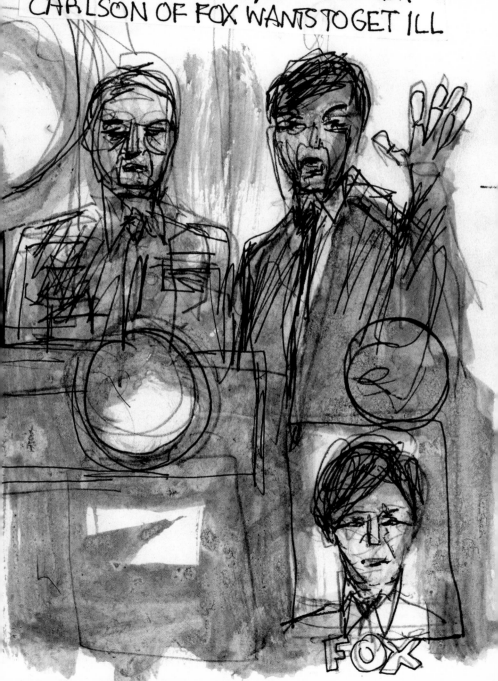

THE UKRAINE PRESIDENT TELLS THE WEST TO CHILL, BUT TUCKER CARLSON OF FOX WANTS TO GET ILL

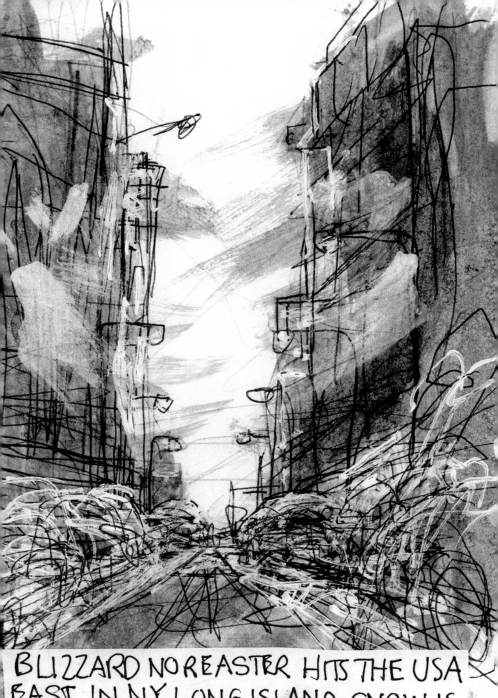

BLIZZARD NOR EASTER HITS THE USA
EAST IN NY LONG ISLAND SNOW IS
COMING DOWN 3 FEET DEEP!

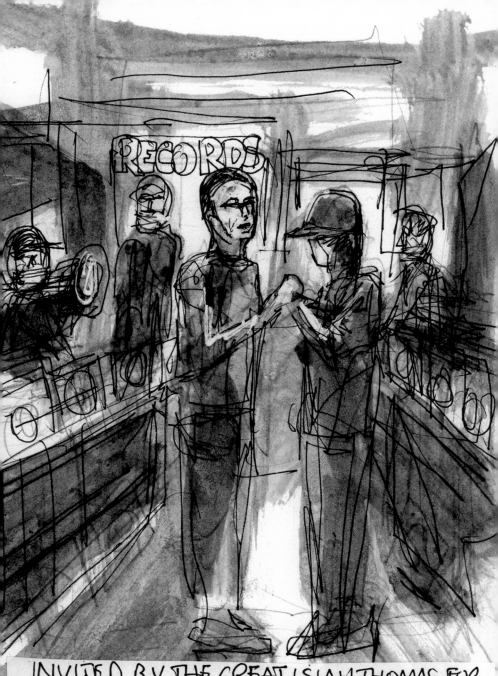

INVITED BY THE GREAT ISIAH THOMAS FOR THE NBA CNTNT, WE TALK ABOUT MUSIC AND BASKETBALL IN A RECORD STORE IN NYC

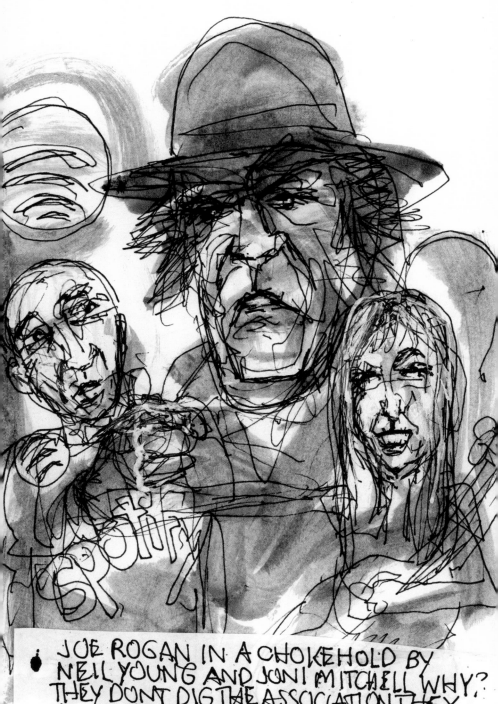

JOE ROGAN IN A CHOKEHOLD BY
NEIL YOUNG AND JONI MITCHELL WHY?
THEY DONT DIG THE ASSOCIATION THEY
ALL SHARE ON SPOTIFY

INFRASTRUCTURE FALLING APART IN THE USA AS A BRIDGE COLLAPSES INTO THE RIVER NEAR PITTSBURGH PA

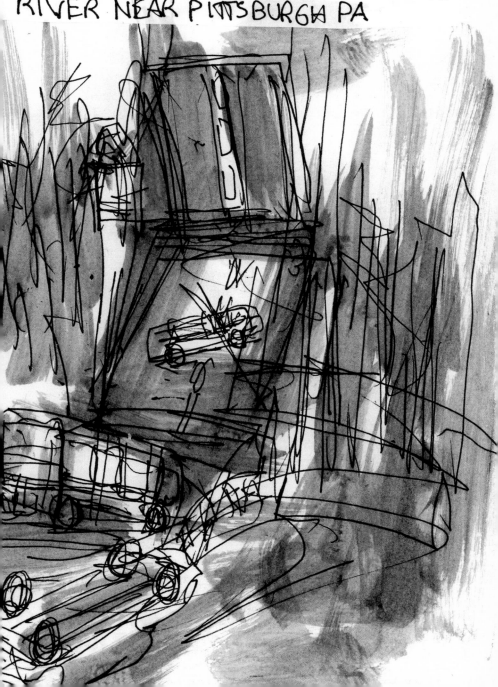

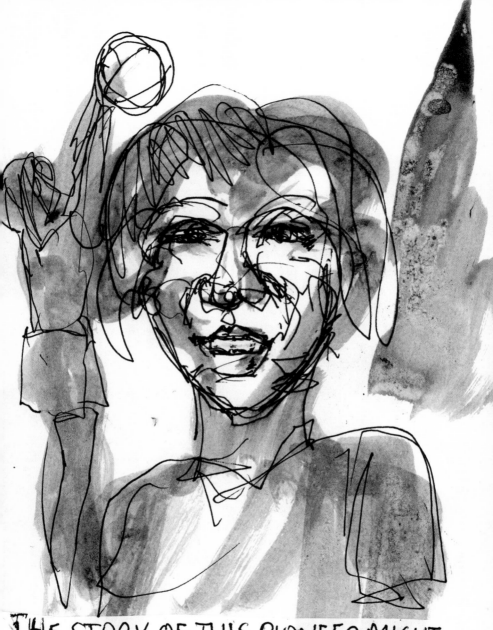

THE STORY OF THIS PIONEER MIGHT
SOUND TRAGIC, BUT SHAQ GAVE THIS
WOMAN FLOWERS WITH A DOCUMENTARY
FOR THE GREATNESS OF LUCY HARRIS

JANUARY 6 2022 A YEAR SINCE THE
INSURRECTION MESS HAS THE NATION
ON EDGE, AND CITIZENS NOW TESTED

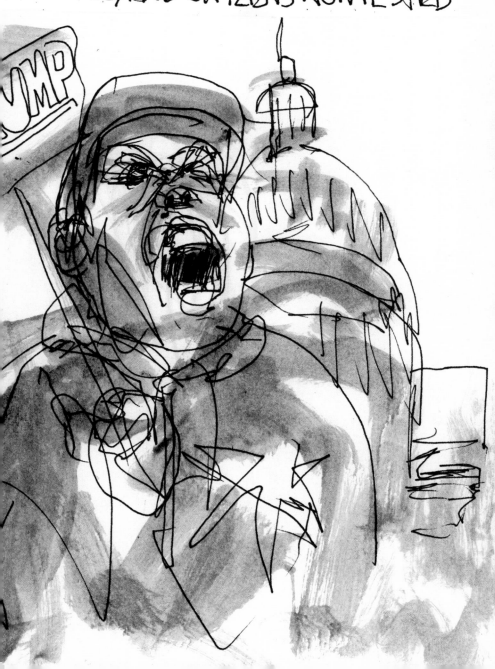

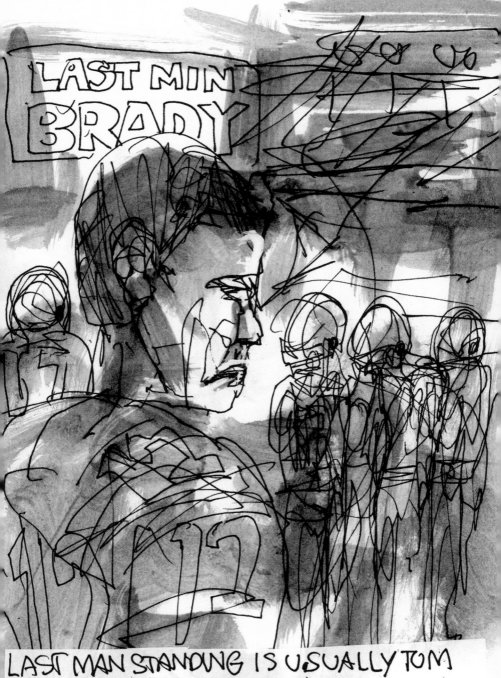

LAST MAN STANDING IS USUALLY TOM
BRADY LAST MINUTE PROBLEM STILL
DRIVES THE OTHER TEAM AND FANS CRAZY

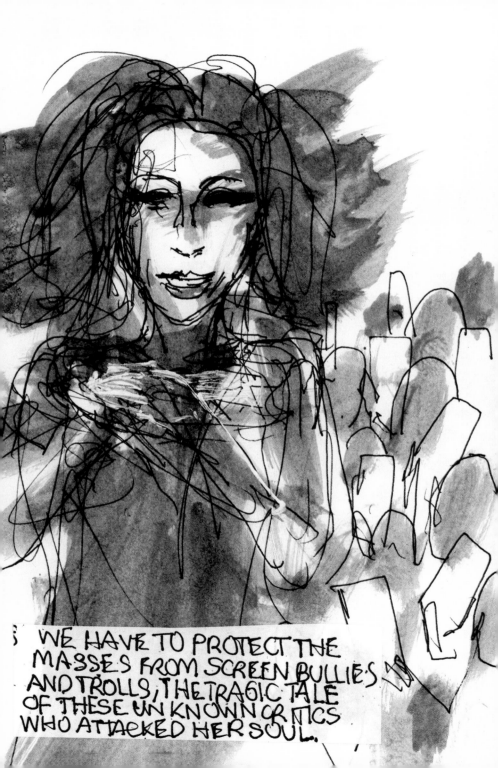

WE HAVE TO PROTECT THE MASSES FROM SCREEN BULLIES AND TROLLS, THE TRAGIC TALE OF THESE UNKNOWN CRITICS WHO ATTACKED HER SOUL.

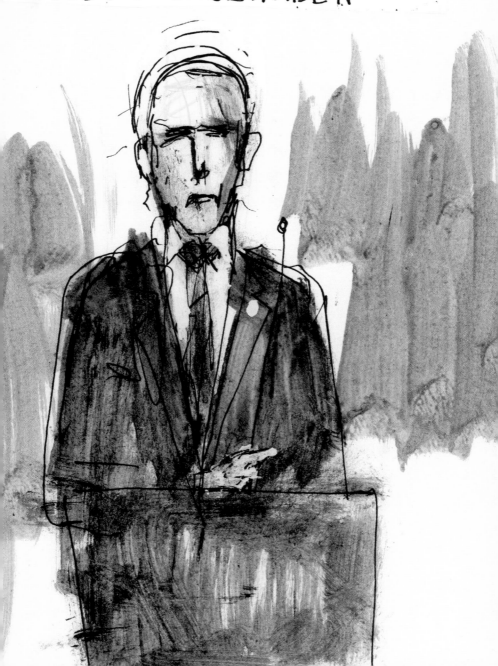

THE GREAT DIVIDE GOT WIDER WITH PENCE DENOUNCING 45 AND HE COULD NO LONGER HIDE IT

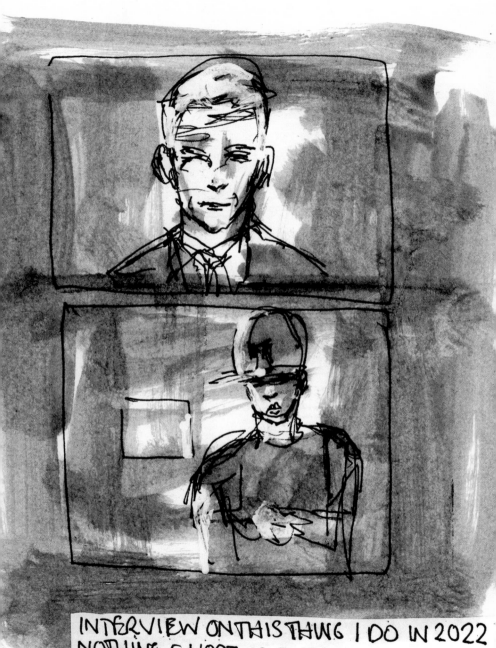

INTERVIEW ON THIS THING I DO IN 2022
NOTHING SHORT OF SUPER; ITS CNN
FULL CIRCLE YOURS TRULY AND
ANDERSON COOPER

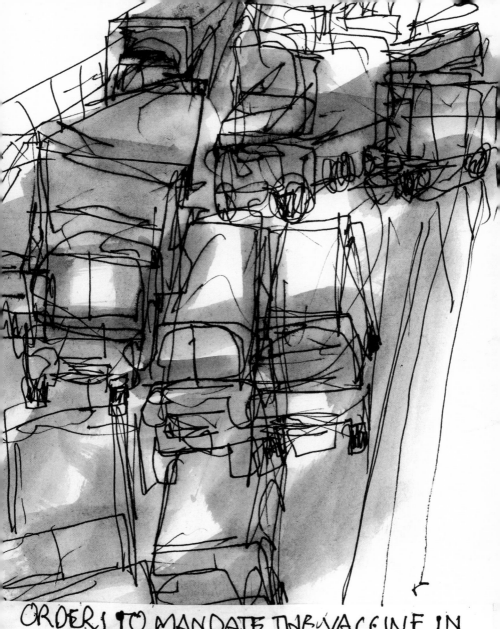

ORDERS TO MANDATE THE VACCINE IN
TRUCK PROTEST OVER THE WATER, THE
AMBASSADOR BRIDGE ENTRY IS CLOGGED
BY TRUCKS STOPPING AT THE BORDER
DETROIT MICHIGAN TO WINDSOR CANADA

WHAT KEEPS ME GOIN ON IS MY DAD WORDS IN ME STRONG, THUS ITS BEEN 6 YEARS TO THE DAY OF THIS DRAWING, THUS HE CAN NEVER REALLY EVER BE GONE....

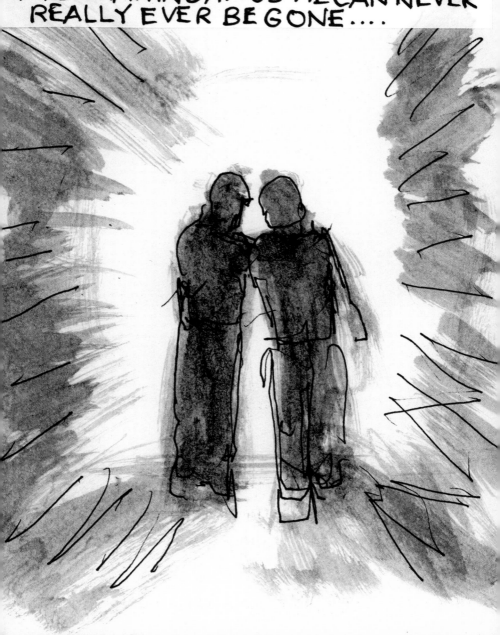

SIGNS OF THIS TIME, HINTS OF WAR IN 2022, BOMB THREATS ON COLLEGE CAMPUSES ESPECIALLY THOSE TARGETED H.B.C.Us